現代商業美術全集

全二十四巻

ARS

現代商業美術全集
THE COMPLETE COMMERCIAL ARTIST

MAKING MODERN DESIGN IN JAPAN
1928–1930

SELECTED PAGES FROM ALL 24 VOLUMES
WITH TEXT BY GENNIFER WEISENFELD

Letterform Archive

CONTENTS

Introduction by Gennifer Weisenfeld ⋯⋯⋯⋯⋯ 10
Selected Pages from Volumes 1–24 ⋯⋯⋯⋯⋯ 46

VOLUME 1 ⋯⋯⋯⋯⋯ 48
世界各国ポスター集
Posters from All
Over the World

VOLUME 2 ⋯⋯⋯⋯⋯ 60
実用ポスター図案集
Practical Poster Designs

VOLUME 3 ⋯⋯⋯⋯⋯ 80
世界模範ショーウヰンドー集
World Model
Show Windows

VOLUME 4 ⋯⋯⋯⋯⋯ 88
各種ショーウヰンドー装置集
Various Equipment
for Show Windows

VOLUME 5 ⋯⋯⋯⋯⋯ 100
各種ショーウヰンドー背景集
Various Backgrounds
for Show Windows

VOLUME 6 ⋯⋯⋯⋯⋯ 118
世界各国看板集
Signboards from
All Over the World

VOLUME 7 ⋯⋯⋯⋯⋯ 130
実用看板意匠集
Designs for Practical
Signboards

VOLUME 8 ⋯⋯⋯⋯⋯ 158
電気応用広告集
Advertisements
with Electricity

VOLUME 9 ⋯⋯⋯⋯⋯ 176
店頭店内設備集
Store Interior Equipment

VOLUME 10 ⋯⋯⋯⋯⋯ 186
売出し街頭装飾集
Street Sales Decorations

VOLUME 11 ⋯⋯⋯⋯⋯ 206
出品陳列装飾集
Exhibition Display Decorations

VOLUME 12 ⋯⋯⋯⋯⋯ 214
包紙・容器意匠図案集
Wrapping Paper and
Container Design

VOLUME 13 ・・・・・・・・・・ **234**
新聞雑誌広告作例集
Examples of Newspaper and
Magazine Advertisements

VOLUME 14 ・・・・・・・・・・ **244**
写真及漫画応用広告集
Advertisements with
Photography and Cartoons

VOLUME 15 ・・・・・・・・・・ **262**
実用図案文字集
Applied Lettering Design

VOLUME 16 ・・・・・・・・・・ **288**
実用カット図案集
Applied Illustration Design

VOLUME 17 ・・・・・・・・・・ **302**
文字の配列と文案集
Lettering Layout
and Copywriting

VOLUME 18 ・・・・・・・・・・ **310**
チラシ・レッテル図案集
Flyer and Label Design

VOLUME 19 ・・・・・・・・・・ **324**
新案商標・モノグラム集
New Trademarks
and Monograms

VOLUME 20 ・・・・・・・・・・ **334**
小印刷物及型物図案集
Small Printed Matter
and Pattern Design

VOLUME 21 ・・・・・・・・・・ **360**
カタログ・パンフレツト表紙図案集
Catalog and
Pamphlet Cover Design

VOLUME 22 ・・・・・・・・・・ **374**
日本趣味広告物集
Advertisements in
Japanese Taste

VOLUME 23 ・・・・・・・・・・ **398**
最新傾向広告集
Latest Trends in Advertising

VOLUME 24 ・・・・・・・・・・ **406**
商業美術総論
Introduction to Commercial Art

From "Introduction to Commercial Art" by Hamada Masuji ・ **414**
Selected Biographies ・・・・・・・・・・・・・・・・・・・ **419**
Index ・・・・・・・・・・・・・・・・・・・・・・・・・・・・ **427**
Credits & Acknowledgments ・・・・・・・・・・・・・・ **431**

現代商業美術全集

2 3 4 5 6 7 8 9 10 11 12 13 14 15

ARS ARS ARS ARS ARS ARS ARS ARS ARS ARS ARS ARS ARS ARS

現代商業美術全集

| II | III | V | VI | VII | VIII | X | XI | XII | XIII | XV |

第一回配本 / 第二十一回配本 / 第二回配本 / 第二十二回配本 / 第四回配本 / 第十七回配本 / 第十回配本 / 第六回配本 / 第十五回配本 / 第九回配本 / 第十二回配本 / 第三回配本 / 第十八回配本

ARS

TRICOLOR PRINTING (*GENSHOKUBAN*)

ORIGINAL DESIGNS PRINTED IN SPOT COLORS WITH OFFSET PLATES (*GENSHOKU OFUSETTO BAN*)

LECTURES AND COMMENTARY (*KŌWA OYOBI KAISETSU*)

Every page of vol. 2, presented in sequence with labeled sections.

BACK COVER

COLOPHON

TABLE OF CONTENTS TITLE PAGE COVER

SINGLE-COLOR PHOTO PRINTING (SHASHINBAN)

VOLUME 2

INTRODUCTION

BY GENNIFER WEISENFELD

From 1928 to 1930, Tokyo-based publisher Ars アルス issued a major twenty-four–volume illustrated compendium of commercial design with extensive annotation and theoretical analysis titled *Gendai shōgyō bijutsu zenshū* 現代商業美術全集 in Japanese and *The Complete Commercial Artist* in English.[1] With more than two-thirds of each volume comprised of illustrations, this landmark production served as a rich trove of design ideas—all at one's fingertips—for easy reference or adaptation. Essay contributors included seventy-one well-known professional practitioners, educators, and journalists active in the Japanese design field.[2]

The series appeared in both hardcover (price 1.5 yen) and softcover (price 1 yen) editions, and Ars distributed it through direct subscription sales, with each volume totaling about 150 pages (FIGURE 1).[3] Most volumes include four separately numbered sections distinguished by methods of printing: First appear two or three pages of tricolor printing (*genshokuban*), then a section of single-color photo printing (*shashinban*), next a vibrant section of original designs printed in spot colors with offset plates (*genshoku ofusetto ban*), and finally a letterpress-printed section of lectures and commentary (*kōwa oyobi kaisetsu*). Each volume also included a thin supplementary gazette titled *Commercial Art Monthly* (*Shōgyō bijutsu geppō* 商業美術月報), with additional information and published letters from subscribers (FIGURE 2).[4] Subscription copies were sold primarily to Japanese commercial retailers and manufacturers, as well as to printing companies and design schools throughout the country. They were also distributed across Japan's expanding empire in Asia, where access to such current visual information was limited. As their printed publication dates indicate, the volumes were not issued in order.[5]

FIGURE 1, FROM LEFT TO RIGHT Hardcover edition, slipcase for the paperback edition, and paperback edition of *The Complete Commercial Artist* (*Gendai shōgyō bijutsu zenshū*; subsequently abbreviated *TCCA*), 1928–1930, offset and letterpress, 10⅜ × 7½ inches (26.5 × 19 cm), Tokyo. While unattributed, these cover designs owe something to the influence, and possibly the direct involvement, of designer and editorial committee member Sugiura Hisui. (For a view of the paperback and slipcase spines for volumes 1–16, see pages 6–7.)

At once encyclopedic and carrying a manifesto-like charge, *The Complete Commercial Artist* was both an important record of original design work by named artists from the period and an invaluable trade publication for disseminating the most up-to-date design practices. It provided a service particularly valuable to small retail shops unable to employ full-time designers but seeking to invest their advertising and displays with the latest creative aesthetics. Not only did the series highlight new styles from around the globe, encouraging designers to suffuse commodities with a fashionable aura, but it also introduced new technologies and materials associated with modern industry to create exciting spectacles for the consumer. The Ars series was one of the most important Japanese design compendia and educational guidebooks published at this time, and its appearance indicated the growing contemporary market for explanatory design texts in Japan as the commercial art field rapidly expanded domestically and around the world.[6]

For the first fifteen numbered volumes, six editorial committee members guided the project, including Sugiura Hisui 杉浦非水 (1876–1965), renowned principal designer for the Mitsukoshi department store; Watanabe Soshū 渡辺素舟 (1890–1986), a well-known author on decorative arts and crafts and a soon-to-be-professor of design at the Imperial Art School (now Musashino Art University)[7]; Tatsuke Yoichirō 田附与一郎 (a.k.a. 田附與一郎; active after 1920), director of the Japanese Advertising Study Association; Miyashita Takao 宮下孝雄 (1890–1972), professor of industrial arts at the Tokyo Higher School of Arts and Technology; and Hamada Masuji 濱田増治 (1892–1938) and Nakada Sadanosuke 仲田定之助 (1888–1970), director and managing committee member, respectively,[8] of the Commercial Artists Association (CAA; Shōgyō Bijutsuka Kyōkai 商業美術家協会).[9] It is clear, however, that among these editors, Hamada was the driving force of the series from its inception, and during the course of its production he was elevated to the role of chief editor. All the editors contributed at least one essay to the total 158 in the Ars compendium, but Hamada dominated the list, authoring thirty-two, with Miyashita penning the next highest number at ten.[10]

While the Japanese term for commercial art or *shōgyō bijutsu* now principally refers to two-dimensional graphic design, in the late 1920s and in the series it was a more inclusive term, encompassing three-dimensional forms used for advertising, such as show windows and architectural structures like kiosks and storefront designs. The definition also overlapped with elements of industrial design, including product packaging. Commercial art functioned both on the printed page and on-site in commercial spaces. The street sales decoration (*uridashi*

FIGURE 2 *Commercial Art Monthly* (*Shōgyō bijutsu geppō*), no. 15, December 1929, distributed with vol. 11 of *TCCA*, letterpress, 10¼ × 7½ inches (26 × 19 cm), Tokyo.

FIGURE 3. TOP LEFT Mori Kimio, design for a structural signboard, *TCCA*, vol. 7, page 50, September 1928. TOP RIGHT Hamada Masuji, design for show window equipment, *TCCA*, vol. 4, page 12, January 1929. BOTTOM Street decorations in Tokyo's Ginza shopping and entertainment district, circa 1920s.

gaitō sōshoku), for example, was a temporary addition to the front of a commercial building. According to essays in the series, these structures were designed to elicit a psychological response from pedestrians by piquing their curiosity. They relied on the assumption that if one person stopped, soon a crowd would congregate.[11] As a gateway to the exposition of commodities within, the decorative entrance, whether an arch or a pillar, aimed to produce an atmosphere of excitement. Slick modern materials like glass, metal, and electric lighting went a long way toward facilitating this effect—as did the creatively designed letterforms that labeled these marquees (FIGURE 3).

Hamada Masuji himself coined the Japanese term for commercial art, *shōgyō bijutsu*, around 1926, offering it as a direct translation from the English to serve as a "general term for all applied art."[12] By 1932, this term was in common use and appeared in standard reference publications. Commercial art was, in Hamada's words, a form of "artistic industry" (*bijutsuteki sangyō*).[13] But it was not, he further clarified, merely any art used in advertising, such as the ubiquitous paintings of beautiful women (*bijinga*), which frequently appeared in publicity materials extending back over two centuries. Rather, it was art that formally and intentionally embodied its commercial function. This definition importantly included visual communication constructed through printed text, ranging from logotype designs to mass media publicity. After Hamada and a group of eleven young colleagues established the Commercial Artists Association on April 24, 1926, other chapters soon began forming throughout the country.[14] This moment marked a newly emerging awareness in Japan of the artistic, social, and economic value of commercial art, providing the impetus to publish *The Complete Commercial Artist*.

DESIGN IN MODERN JAPAN

Design was traditionally considered an artisanal field in Japan, and activists worked to establish it as a major area of artistic endeavor in the first few decades of the twentieth century. The gradual recognition of design's aesthetic, as well as its functional value in the sphere of Japanese visual arts, have shaped its evolution and defined its central cultural importance ever since. Its new social status was not a coincidental development. As evident in the case of Hamada, designers and design theorists, like the contributors to *The Complete Commercial Artist*, consciously and aggressively forged that status, seeking aesthetic and social legitimacy for the profession. Japanese design historians have charted a gradual conceptual shift around the turn of the century from the longstanding artisanal notion of design (*ishō*) based on sets of forms and patterns (*hinagata* or *kata*) to one that implied more personal autonomy and professional standing on the part of the designer, expressed in the increasingly common terms *shōgyō bijutsu*, *zuan* (design), and later *dezain* (design). Such new perceptions of design were emerging around the globe, and it is important to note that the anglophone term "graphic designer," usually attributed to American designer William Addison Dwiggins, had just started to gain currency around 1922. The phrase denoted the professional sphere of applied printing, including letter design, typography, book design, packaging, ephemera, posters, and press advertisements.[15]

Commercial art came to the fore in Japan during the period between the end of the Russo-Japanese War in 1905 and Japan's invasion of Manchuria in 1931, when many cultural forms underwent commodification and merged into mass culture. The importation of new technologies from Europe and the United States beginning in the late nineteenth century brought a momentous change in the relationship between culture and industry in Japan. Innovations such as the rotary press, wireless telegraphy, photography, radio, movies, recording technology, and railroads enabled the production of a cheap and easily reproducible culture that could disseminate efficiently throughout the nation. What scholars have termed a modern culture industry, consisting of mass publishing, mass media, and mass entertainment, relied on these new technologies. The massification (*taishūka*) of Japanese culture was also predicated on the cultivation of a literate consumer public extending beyond the elite classes of society. The implementation of a nationwide education system in 1872 significantly increased literacy and facilitated this trend.

A rapid boom in consumerism produced valuable work opportunities for Japanese artists in the commercial sector. Many establishments, including department stores and major manufacturers, launched internal design divisions to create effective visual and verbal strategies for advertising and marketing their products. These divisions often employed artist-designers, many of whom, after studying at prestigious art schools and private ateliers around the country, became specialists in commercial design. At the same time, a host of new design and craft schools was springing up around Japan, most notable among them the Tokyo Higher School of Arts and Technology (Tōkyō Kōtō Kōgei Gakkō 東京高等工芸学校), where Miyashita Takao and many other contributors to *The Complete Commercial Artist* taught or studied. The school opened in 1922 to meet the demands of increased industrial production and commercial activity.[16] Individual groups and companies all over Japan began sponsoring academic study sessions concentrated on analyzing modern trends in advertising and design. These activities were so widespread that design historian Kawahata Naomichi has dubbed the 1930s "the era of design study groups," identifying over sixty associations known to have formed during this time.[17]

Modern design was a dynamic sphere of knowledge production that spanned the globe, engaging Japanese art and design in long-running aesthetic dialogues that increasingly happened in real time. The craze for Japanese woodblock prints in the nineteenth century, as well as for the country's traditional and export-style decorative arts exhibited at world's fairs, is credited with igniting the widespread *Japonisme* boom across Euro-America. *Japonisme* was a critical contributor to the aesthetic movements of art nouveau and later art deco, which modern Japanese design then enthusiastically reabsorbed and reinterpreted. By the time Ars published the compendium, Japanese design trade publications were participating in a global conversation with corresponding publications across Europe and the United States. This constituted a transcultural and transnational traffic of ideas and images circulating on media highways that flowed in all directions. In the 1920s, the Japanese commercial art community was familiar with most of the major Western design and advertising trade publications, including German titles like *Die Reklame* (*The Advertisement*) and the British journal *The Studio*, and the information these journals presented played a critical role in the instrumentalization of modern styles. Translated excerpts from original publications and editorial commentaries by Japanese critics frequently accompanied copious journal illustrations. In an age of lax or nonexistent copyright laws, Japanese publishers were able to reissue foreign images with impunity.

The preeminent German graphic design publication *Gebrauchsgraphik: Monatsschrift zur Förderung künstlerischer Reklame* (*Commercial Graphics: Monthly Magazine for Promoting Art in Advertising*), edited by H. K. (Hermann Karl) Frenzel (1882–1937), was widely known throughout the Japanese commercial art community, which recognized Germany as an important center of professional design activity. It was published bilingually in German and English in Berlin from 1924 to 1944, and as one of the earliest professional graphic design journals in Europe, it served as a model for design trade journals around the world. It also became the official organ of the Association of German Graphic Artists (Bundes Deutscher Gebrauchsgraphiker), guaranteeing it a sizable readership. In 1927, just a few years after the journal's establishment, the editorial board, recognizing the international nature of the emerging field, augmented the name with the subtitle *International Advertising Art*. While the journal largely limited its definition of internationality to Western Europe and North America, it did feature and discuss work from other regions and countries, including Japan. Other prominent journals, like *Commercial Art*, published in London and New York, similarly included sections such as "Advertising from All Quarters" to spotlight work from around the world (FIGURE 4).[18]

Offering Japanese designers a window into world design practices in the 1920s and 1930s, international trade journals like *Gebrauchsgraphik* also interpreted work by Japanese makers, though often in essentializing terms defined within a narrow spectrum of identity politics. This fact reflected an underlying tension in design discourse between nationalism and internationalism, the local and the universal. Some writers in *Gebrauchsgraphik*, including Frenzel himself, argued that the spread of international commerce was increasingly blurring

FIGURE 4, FROM LEFT TO RIGHT *Gebrauchsgraphik* (*Commercial Graphics*), vol. 1, no. 11, November 1924, offset, 12⅝ × 9⅝ inches (32 × 24.5 cm), Berlin. *Die Reklame* (*The Advertisement*), vol. 19, no. 1, October 1926, offset, 12 × 9½ inches (30.5 × 24 cm), Berlin. *Commercial Art*, vol. 4, no. 10, August 1925, 11¼ × 8⅝ inches (28.5 × 22 cm), London.

"the contours of artistic form in the individual nations," destroying what was formerly known as "'Volkskunst'—the art of the people."[19] But many others remained invested in articulating national, ethnicized differences in design, specifically between the West and "non-West," by identifying visual precedents in earlier pictorial traditions. Even Japanese commercial artists like Satomi Munetsugu 里見宗次 (1904–1996), who had permanently resided abroad in Paris since the age of seventeen, were described in ethnicized terms: "His outlook is French; his love of accurate arrangement, Japanese; the two combined give his work the curious and attractive personality which has brought him success."[20] Still other writers were openly contemptuous of contemporary Japan's design efforts, which they perceived as mistakenly straying from local traditions. In an article for *Gebrauchsgraphik* in 1927, Eduard Wildhagen proclaimed that despite a long and illustrious history of creative advertising, "it seems as if the Japanese, abandoned by all the good spirits of his immediate past, had delivered up the art of advertisement to crude daubers and dilettante students." He instead praised traditional Japanese woodblock prints and family crest symbols as the perfect precursors of modern advertising:

> Old Japan deserves on the score of its former achievements to be called the classic land of advertisement and poster art. In the course of a long artistic development, it has collected for future use all the elements of propagandistic art in its most perfect form as no other civilized country has done.[21]

The editors of *The Complete Commercial Artist* shared Wildhagen's interest in Japanese graphic history, as evidenced both by articles in the series that address this topic and by the choice to devote volume 22 to "Advertisements in Japanese Taste." One illustration of signboards (*kanban*) from this volume portrays the striking and clever variety of means devised to broadcast shops and services in Japan's Edo period (1603–1868) (FIGURE 5). However, Japanese designers and trade journals were mostly interested in design's contemporary, transnational, and universal qualities in an increasingly global marketplace, often highlighting their tensions and interplay with the distinct nature of national production.

Commenting on this viewpoint, Harada Jirō 原田治郎 (1878–1963), cultural critic and advisory board member for *The Complete Commercial Artist*, noted in *Commercial Art* that to attract the attention of the contemporary Japanese public, it was essential to use something "exotic" in the marketplace, "something different from traditional form." The new devices of advertising in Japan were, according to Harada, intrinsically associated

FIGURE 5 Detail of an uncredited illustration of characteristic Edo-period signboards, *TCCA*, vol. 22, page 40, June 1930.

with a "foreign method," and, as he pointed out, the Japanese public repeatedly clamored for them. However, because there were Japanese who reacted against this "intoxication" with things Western, some artists endeavored to develop new work with traditional methods "to infuse a new life into the old form." And despite "the absence of a Japanese flavor" in contemporary advertising design, he argued, "ethnic characteristics" were "bound to reveal themselves" down the line. Harada emphasized that whatever their method, Japanese commercial artists shared the aim "not only to attract the attention of the people to a poster or a show window, but to arrest [their attention] upon the ware [these] advertise and excite the mind of the observer, leading him to buy the goods." This objective, Harada concluded, could only be attained by a careful study of the local "community psychology," which inevitably changed over time.[22] Thus, domestic context was critical even in an increasingly globalizing design world, as nations had a shared and evolving community psychology that overtly or covertly informed national style.

As with *Gebrauchsgraphik*, progressive artist-designers abroad pioneered many of the artistic styles and techniques covered in *The Complete Commercial Artist*. Those artists included Russian and international constructivists, the Dutch followers of De Stijl, and especially the diverse group at the German avant-garde art school the Bauhaus, who were attempting to integrate fine art with social praxis through design. Reflected, for instance, in a set of illuminated signs by German designer Walter Dexel reproduced in the series, their work was predicated on the notion that a designed environment could alter the perception and action of its inhabitants (FIGURE 6). Artists associated with the Bauhaus figured prominently in the illustrated examples accompanying Hamada Masuji's major theoretical essay in the final volume of the series. His close colleague and fellow editorial committee member, Nakada Sadanosuke, was an avid Bauhaus proponent who had visited the school in the early 1920s and was among the first to introduce its work to a Japanese audience beginning in 1925.[23] He contributed five essays to four volumes in the series, commenting on Bauhaus experiments in the simplification of typographic design, the use of modernist photography in advertising design, the international constructivist work of Hungarian avant-garde designer Lajos Kassák, and new trends in modern book design.[24]

Considering this strong internationalist orientation, the publication's articulation of commercial art corresponded with developments in Euro-American design that art historian

FIGURE 6 Detail of a page with illuminated signs for German businesses by constructivist designer Walter Dexel, *TCCA*, vol. 7, page 47, September 1928.

Paul Greenhalgh has designated the "pioneer phase" of the international "modern movement," extending from World War I until the early 1930s.[25] Greenhalgh refers to a group of avant-garde artist-designers who, like their Japanese counterparts, put forth a vision of how the designed world could transform human consciousness and improve material conditions. These designers tended to have a holistic and absolutist worldview, and their foremost concern was to break down barriers between aesthetics, technology, and society to produce works for the masses.[26] Hamada's capstone essay for *The Complete Commercial Artist* (see pages 414-18) was exemplary in this regard. Informed by Marxist theories of culture, Hamada proclaimed that "pure art" (roughly, fine art) was "controlled by bourgeois ideology" and served only the needs of the ruling class. It was his foremost goal to redress this artistic hierarchy by elevating commercial art to the level of pure art. Due to its intrinsically compelling nature, commercial art, Hamada felt, would eventually eclipse all forms of art for art's sake as part of a more egalitarian society.[27] In the meantime, just naming the field was a significant act in the contemporary climate of the Japanese art world, as it identified a vast realm of artistic production that went entirely unacknowledged. Hamada lamented that "in some respects, it can be said that *shōgyō bijutsu* has not yet been born in Japan."[28]

Indeed, out of all the full-time Japanese designers working during the prewar period, only a handful gained public recognition. For high-visibility projects, businesses often commissioned artists well established in the world of fine arts to paint works that the clients would then use for advertising purposes. Such paintings were generally not intended to represent a particular product or industry. Rather, businesses sought to invest their trades with the refined image of fine art, thereby distancing themselves from direct association with commerce. This effort reflected a persistent Edo-period social bias against direct involvement with commercial activity—one partially rooted in neo-Confucian morality, which did not value merchants who, because they did not produce anything, were not thought to contribute to society. Thus, posters of beautiful women, which had been used for hundreds of years to represent style, sophistication, and elegance, were still the most appealing option for promotional purposes. *Portrait of a Woman* (1907), by renowned academic oil painter Okada Saburōsuke 岡田三郎助 (1869–1939), for example, was quickly adapted into the now famous Mitsukoshi department store poster with the simple addition of the store's name (FIGURE 7). Like many of his academic colleagues—including his illustrious teacher, premier Western-style painting master and design

FIGURE 7 Okada Saburōsuke, *Portrait of a Woman* reproduced as a poster for the Mitsukoshi department store, 1909, offset, 28⅞ × 24¼ inches (73.25 × 61.5 cm), Tokyo. Okada completed his original painting in 1907 in oil on canvas.

FIGURE 8 Sugiura Hisui at an exhibition of his book bindings and magazine covers at the Hibiya Library in Tokyo, 1912.

proponent Kuroda Seiki 黒田清輝 (1866–1924)—Okada produced paintings for commercial use throughout his career. Magazine covers and other illustrations, such as a yearlong series for *The Housewife's Companion* (*Shufu no tomo* 主婦の友) in 1923 and a commemorative calendar for the same publication in 1927, were just a few examples. Still, the professional identity of these artists remained solidly situated within the lofty precinct of the fine arts.[29]

One artist-designer who was able to establish a public reputation in the graphic arts, paving the way for activists in the design field, was undoubtedly Sugiura Hisui (FIGURE 8). An editorial committee member for the Ars series, Sugiura was the chief designer at the Mitsukoshi department store from 1910 to 1934. He also trained under the tutelage of Kuroda Seiki as a student at the prestigious Tokyo School of Fine Arts. From Kuroda, who had attended the 1900 Exposition Universelle in Paris, Sugiura absorbed a deep appreciation for French art nouveau. Sugiura's career demonstrates the deep entanglements of cultural criticism, pedagogy, commercial entrepreneurship, and statecraft. His popular designs, first inspired by art nouveau and later by art deco, circulated widely through several very successful, commercially published design portfolios, catapulting him into national recognition in the Japanese art world.[30] His designs were so well known that people referred to him as "Mitsukoshi's Hisui" or to the store as "Hisui's Mitsukoshi."

Most of Sugiura's designs still relied on elements of the *bijinga* or beautiful woman artistic tradition, but they displayed a new concern for graphically accentuating the identity of the sponsor. For instance, some directly incorporated the modern

FIGURE 9, FROM LEFT TO RIGHT Sugiura Hisui, *Mitsukoshi: Show of New Spring Patterns*, 1914, offset, 41½ × 30 inches (105.5 × 76.5 cm), Tokyo; *Mitsukoshi: Renewal of the Western Building of the Main Store and Completion of the Shinjuku Branch*, 1925, offset, 42 × 29 inches (106.5 × 73.75 cm), Tokyo; *The Only Subway in the East*, 1927, offset, 36⅛ × 24⅜ inches (91.75 × 62 cm), Tokyo. Mitsukoshi's flagship building appears in the background of the middle poster. The far-right poster, commissioned for the opening of the Tokyo subway, was reproduced in vol. 2 of *TCCA*.

architectural structures of department store buildings. Others represented the store synecdochically in posters through the display of its promotional magazine, *Mitsukoshi*, well known for publicizing new consumer trends. One widely circulated image conspicuously presented the magazine on the lap of a seated female figure, quickly recognizable as an example of the "new woman" (*atarashii onna*) by her hairstyle, apparel, and modern domestic surroundings (FIGURE 9, LEFT). The juxtaposition implied a direct connection between the store and the woman's stylish modern lifestyle. Sugiura's solid training in the fine arts under Kuroda, and his strong personal ties to the fine arts community, gave his design endeavors social status to which others of equal ability could only have aspired. He used his position to promote the graphic arts in the public eye and within art education.

In 1924, after a trip to Europe, Sugiura formed a design study association called the Group of Seven (Shichininsha 七人社), which held annual poster shows of domestic and international work from 1926 to 1936. Soon after its founding, the group began publishing its own journal, *Affiches* アフィッシュ (*Posters*; 1927, 1929–1930), Japan's first design magazine (FIGURE 10).[31] The journal changed its initial subtitle of *Magazine for the Study of Posters* (*Posutā kenkyū zasshi*) in November 1929 to *Magazine for the Study of Design* (*Zuan kenkyū zasshi*), adding the French phrase *Revue mensuelle aux artistes décorateurs* (*Monthly Review for Decorative Artists*) to indicate its broadening purview. Significantly, *Affiches* illustrated and discussed global designs from England, Italy, France, Germany, Russia, Switzerland, Poland, Czechoslovakia, Belgium, Hungary, the Netherlands, and Ireland. Taking his lead from European art nouveau designers, Sugiura supported the *Gesamtkunstwerk* ideal of designing the entire lived environment. Perhaps one of his greatest contributions as a design proponent in Japan was the introduction

of the concept of total design. Sugiura's legacy in design pedagogy is preserved at the prestigious Tama Imperial Art School (Tama Teikoku Bijutsu Gakkō 多摩帝国美術学校; now Tama Art University), which he helped found in 1935 and where he served as school president for many years.[32]

In *The Complete Commercial Artist*, Sugiura championed posters as the new art of modernity. His rallying cry in *Affiches*, "Words for the First Issue," unabashedly proclaimed the artistic validity of "creative posters" (*sōsaku posutā*), which claimed pride of place as the subject of volumes 1 and 2 of the Ars compendium. He wrote:

> Japan's business world (*jitsugyō shakai*), its workers, and artists alike have finally opened their eyes to posters ... and commercial design (*shōgyō zuan*). World War I was the catalyst for this. It can be said that this study and the demands for it finally caught on [in Japan] right after the Great Kantō Earthquake [of 1923]. However, the problem of how to develop advertising art (*kōkoku bijutsu*) is not just Japan's problem. In fact, since Japan has been influenced by several Euro-American countries, it is part of a world situation. For example, when the magazine *The Studio* calls for commercial art to secede from fine art, we see the same impulse expressed in Japanese magazines that say industrial arts (*kōgei*) should secede from pure art (*jun bijutsu*). Most artists have not thought about merging art with actual society; they just think of advertising pictures as something risky for art. These are people who only look at this from on high (from an elite and elevated position)—basically they need to get down from their high horses. There are people willing to step down and see the world from an actual social position—I am one of these people.[33]

FIGURE 10, FROM LEFT TO RIGHT Sugiura Hisui, cover designs for *Affiches*, offset, Tokyo: vol. 1, no. 1, 1927, 12⅛ × 9 inches (31 × 23 cm); vol. 1, no. 3, 1927, 12⅛ × 9 inches (31 × 23 cm); vol. 3, no. 6, 1930, 10½ × 7⅜ inches (26.5 × 18.75 cm).

TYPOGRAPHY AND LETTERFORM DESIGN

Innovative and expressive typography in commercial advertising became a major strategy for producing an eye-catching and modern look. As evident across every volume of *The Complete Commercial Artist*, shape, size, hue, and position of printed texts all played a role. Visual and textual elements combined in dynamic compositions, and conscious juxtaposition accented both two- and three-dimensional forms. Designers labored to evoke the pictorial and expressive qualities of letterforms. Of course, this attentiveness to visual language was not new in Japan or in other Asian countries that possessed strong calligraphic traditions. But Japan's experience of modernization and modernity, from the forces of the modern associated with Western countries to the nationalism incipient in Japan's own newly created nation-state, had an especially profound impact on its writing system. In particular, its Chinese-derived characters, known as *kanji*, became the focus of intense debate among cultural reformers, whose proposals ranged widely, from character simplification to complete abolition.

The Japanese written language is a distinct amalgam of logo or ideographic characters (*kanji*), native syllabaries (*kana*; namely *hiragana* and *katakana*), and romanized letters (*rōmaji*) and numbers, offering designers an unparalleled and uniquely challenging range of expressive possibilities (FIGURE 11). Its semantic evolution is the result of centuries of highly mediated transcultural interaction with other Asian and Western languages. Originally derived from ancient Chinese, Japanese written script developed its two complementary phonetic syllabaries to accommodate the distinct polysyllabic and inflected nature of spoken Japanese. The facts of this development, followed by the introduction of Western words and alphanumeric writing systems, are well known.[34] Less so are the Japanese debates on language reform in the late nineteenth and early twentieth centuries, which are equally critical to understanding the status and development of written

FIGURE 11 The words "commercial art" (*shōgyō bijutsu*) in *kanji*, *hiragana*, *katakana*, and *rōmaji* writing systems. *Kanji* (literally "Han characters") make up a logographic script sharing most of its nearly 3,000 characters with traditional Chinese writing. *Katakana* and *hiragana* comprise complete syllabic scripts of 48 basic characters each. Typical uses for *katakana* include transcribing foreign-language words, while *hiragana* is often used for native Japanese words and as a grammatical supplement to *kanji*. Romanized Japanese, written in *rōmaji*, is widely taught in Japan, making it a standard part of the writing system.

KANJI	商業美術
HIRAGANA	しょうぎょうびじゅつ
KATAKANA	ショウギョウビジュツ
RŌMAJI	SHŌGYŌ BIJUTSU

language in the modern period. Standardization, legibility, and access were pressing concerns for both politicians and commercial entrepreneurs in Japan's rapidly emerging national public culture. As renowned designer and type aficionado Hara Hiromu 原弘 (1903–1986) said, "Before the problem of scripts, the problem of national letters (*kokuji*) is an enormous wall that stands in our way."[35] Contentious debates over what should constitute a national written language formed the ideological backdrop to the development of modern letterforms.

Japanese letterforms were also able to exhibit a free-form directionality—something that only entered Western typographic design with the experimentations of modernism. Multidirectionality is inherent in the polyglot nature of the Japanese language and enhances the possibilities of communication through editorial design. When first approaching a page for editorial layout, Japanese designers are confronted with the question of whether the text should read vertically or horizontally, and whether it should be read left to right or right to left—all conventions freighted with ideological as well as aesthetic import, as the language of the new Japanese nation-state deviated from, yet was obliged to conform with, Western writing traditions in the international sphere. Many designers embraced this tremendous aesthetic liberty, especially in the subgenre of lettering for movie advertisements, which came to be known as *kinema moji* (cinema letters) (FIGURE 12).

For most of the twentieth century, the challenges and expense of developing type, as well as the inability of type to simulate adequately the dynamism of calligraphy, meant innovative and expressive letterform designs in Japan largely involved what Kawahata Naomichi has termed *kaki moji*—hand-designed lettering printed lithographically or from plates rather than actual cast typefaces.[36] Modern Japanese designers found that the formal abundance of the *hiragana* and *katakana* syllabaries, Chinese characters, and romanized letters provided fertile ground for experimentation. The boom in design-related trade publishing that took place in the 1920s and '30s significantly included an abundance of lettering compendia and graphic sample books, many published in Osaka, the second-largest city in Japan and a center of commercial activity.[37] One of the first comprehensive explications of typography, *Typographic Handbook* (*Zuan moji taikan* 図案文字大観), was published in 1926 by Yajima Shūichi 矢島週一 (a.k.a. 矢島周一; 1895–1982), a poster designer and later a contributor to *The Complete Commercial Artist*. In the introduction to Yajima's book, Tokyo Imperial University professor and architect Takeda Gōichi 武田五一 (1872–1938) echoed widespread recognition of

FIGURE 12 Yamada Shinkichi, poster with multi-directional text advertising the 1923 German silent film *Crime and Punishment* at the Shōchiku Cinema in Kyoto, 1925, offset, 21 1/8 × 9 7/8 inches (53.75 × 25 cm), Kyoto.

the importance of typography for visual communication and consumption. Stating that "beautiful typography is the most effective way of promoting the worth of a commodity," Takeda argued that modern products demanded new letterforms.[38] Yajima's book answered the call with two thousand standard *kanji* presented in ten varieties of lettering with an additional eighty forms of *katakana* and twenty forms of *hiragana*. Laying out the collection of scripts on an ordered orthogonal grid, Yajima compared their various aesthetic properties and systematically analyzed their relative proportions.

Ultimately interested in breaking down letterforms into their constituent elements in the hope of producing a series of combinable and recombinable forms, Yajima and the editors of *The Complete Commercial Artist* went even further, abstracting and geometricizing *kanji* and *kana*, which they then analyzed in a comparative framework. Example pages by Yajima laid out various permutations of different *hiragana* and *katakana* phonemes (as well as Western alphabets and numerals), displaying the broad variations and widely divergent aesthetic properties with which they could imbue the same letter. Thick and thin, angular and curvaceous, legible and scribbled, plain and decorative—the comparisons are myriad, the options plentiful (FIGURE 13).

The crucial role of lettering and editorial layout in the emergent field of commercial art was in evidence across the field of advertising design. The Ars compendium devoted volumes 15 and 17 to lettering and layout, respectively, and made trademark and monogram design the subject of volume 19. In one example, three columns of the *kanji* character *raku* 楽 (meaning comfort or relaxation) shimmy and repeat down the right side of the page, becoming by turns more animated, abstracted, and decorative (FIGURE 14). Many of the script styles are highly mannered, some are more angular, and others more rounded. Some have distinctive decorative flourishes in the brushstrokes. Eschewing the quest for legibility and standardization, these designs emphasize subjective lyricism, reflecting the aesthetic spirit of what has since been called Taishō romanticism. This spirit, evident throughout *The Complete Commercial Artist*, drew inspiration from the decorative and poetic imagery of the pan-European art nouveau movement and flourished in the heady age of individualism emerging in Taishō period Japan (1912–1926). It emphasized ornate floral patterning and extensive use of decorative flourishes, conveying an overriding image of elegance and luxury (FIGURE 15).

FIGURE 13, TOP Yajima Shūichi, examples showing how to create designed characters, *TCCA*, vol. 15, pages 76–77, April 1930. BOTTOM Yajima Shūichi, designs for Western letters and numbers, *TCCA*, vol. 15, pages 92–93, April 1930.

FIGURE 14 Yajima Shūichi, variations on the *kanji* character 楽 (*raku*), *TCCA*, vol. 15, page 75, April 1930.

FIGURE 15 Unattributed lettering examples, *TCCA*, vol. 15, page 17, April 1930.

A contrasting current of standardization, modularity, and functionalism also appears throughout the series. Internationalism and the perceived need for a universal canon of typographic standards inspired modernist designers in Europe in the 1920s to propose elemental, sans serif typefaces that would be clear and without embellishment—styles known in Japanese as standard letters (*hyōjun moji*). These designers sought to represent the rationalized, machine-production ethos of the modern age. Functionalism and transparency were the objectives, and reducing letters to their basic forms was a means to this end. Bauhaus typography in Germany was among the most representative of this trend, associated with the major design figures Herbert Bayer, Josef Albers, Joost Schmidt, and László Moholy-Nagy. German designer Jan Tschichold articulated its essence in a widely circulated 1925 manifesto, followed by his landmark 1928 book, *The New Typography*. In Japan, avant-garde artist groups like Mavo and its leader, Murayama Tomoyoshi 村山知義 (1901–1977), were instrumental in interpreting these emerging theories of typography and strategies of typographic layout.[39] Three of Murayama's design plans were illustrated in *The Complete Commercial Artist*, including one colorful signboard shaped like a vehicle advertising the 1-yen volumes of the compendium (see page 142, top, of the present book). In his writings, he quotes Moholy-Nagy on the importance of typography in the visual arts:

> Typography ... must be communication in its most intense form. The emphasis must be on absolute clarity.... Priority: Unequivocal clarity in all typographical compositions. Legibility—communication must never be impaired by an a priori aesthetics. Letters may never be forced into a preconceived framework, for instance a square.... The essence and purpose of printing demand an uninhibited use of all linear directions (therefore not only horizontal articulation). We use all typefaces, type sizes, geometric forms, colors, etc.[40]

This cultural standardization, however, was never totalizing, and it was countered on many fronts. Even amid its heavy emphasis on modern expressive letterforms, the Ars compendium gives considerable space to earlier script styles and uses, such as those of calligraphic sumō advertisements, underscoring their relevance to the burgeoning national consumer market (FIGURE 16). The past continued to have meaning in the present, and there was no better example of this than the sustained use of Edo commercial scripts through the twentieth century. Some have since been standardized as typefaces. *The Complete Commercial Artist* showcases examples of well-known Edo-period scripts such as *kakuji*, *botan moji*, *Kanteiryū*, and variants similar to *sumō moji*.

FIGURE 16 Unattributed Edo-period advertisement with sumō-style ranking chart (*mitate banzuke*), *TCCA*, vol. 22, page 3, June 1930, offset, 10⅜ × 7½ inches (26.5 × 19 cm), Tokyo.

(見番付)　刷物によるお日本趣味廣告

A	B	C	D	E
kakuji or *kakumoji* (square characters)	*botan moji* (peony characters)	*Kanteiryū* (Kantei-style characters)	*futo Kanteiryū* (fat Kanteiryū)	*hige moji* (whisker characters)

FIGURE 17 Examples of Edo-period scripts. *TCCA*, vol. 15, pages 7–8 and 11, April 1930.

Kakuji (square characters, also known as *kakumoji*), a form of squared-off, highly stylized characters, were often used in household seals and some crests, as well as in insignias on clothing (FIGURE 17A). *Botan moji* (peony characters), which also often appeared on the backs of *happi* coats, have puffy strokes with wavy contours, with the characters molded into a circular surround that makes them appear like flower buds from above (FIGURE 17B). (Traditionally worn by Japanese shopkeepers, *happi* coats are emblazoned with their commercial crests and now appear predominantly at street festivals.) One popular Edo-period script later codified into a typeface was *Kanteiryū* (Kantei style), which was associated with signage and publications for the Kabuki theater and is now the official Kabuki script. Developed around 1779 by the ninth heir of the Edo-based Nakamura-za 中村座 Kabuki theater, and widely used for all Nakamura-za signage by the painter known as Kantei (Okazakiya Kanroku 岡崎屋勘六; 1746–1805), whose name it bears, *Kanteiryū* is sinuous and displays strong compression, as if each character had been sat upon, leaving very little space between strokes (FIGURE 17C). An example of "fat Kanteiryū" in the Ars volume has corpulent and fleshy strokes (FIGURE 17D). Another popular Edo script was *sumō moji* (sumo script), which, as the name describes, is a form of script specifically associated with sumo wrestling, a sport that has remained popular throughout the modern period. (A similar script appears in the Ars series and is reproduced on page 265, top right, of the present book.) *Sumō moji* features thick, rounded, inky horizontal and vertical strokes.

Volume 15's sample of Edo characters also features two illustrations of *hige moji* (whisker characters). As the name describes, the characters have whisker-like stylized brush trails at the ends of the strokes and simulate the flying white (*hihaku*) calligraphy technique, which accentuates the white streaks and gaps within black *sumi* ink brushstrokes (FIGURE 17E). Whisker characters are still widely used in the commercial sphere for everything from the signs for shaved ice dessert (*kakegori*) that dot city streets in the summer to the backs of *happi* coats. By nature of their association with the Edo period, *hige moji* are coded as traditional.

FIGURE 18 Monograms for sake brands Hakutsuru (left) and Gekkeikan (right). *TCCA*, vol. 19, page 26, September 1929.

Hige moji are also conspicuous on the product label designs of Japanese sake brand names, such as Hakutsuru 白鶴 and Gekkeikan 月桂冠. Examples of company monograms in *The Complete Commercial Artist* reflect how, even as Japanese and overseas markets developed and regional manufacturers transformed themselves into national brands with cultivated corporate images, sake brand identity remained unchanged, not requiring a modern makeover (FIGURE 18). Unlike beverages newer to Japan such as beer or wine, sake had an image that its association with centuries-old traditions of fermentation and brewing enhanced. That remained the case even as much sake production in fact transformed in response to increased consumer demand, and even when producers began to add straight alcohol to the fermented rice wine, a controversial practice to which purists adamantly objected. Coding a product as traditional or as having traditional roots through letterforms reinforced consumer confidence in the quality standards of the company, a technique employed in monograms for the Daimaru 大丸, Mitsukoshi 三越, and Takashimaya 髙島屋 department stores featured in volume 19 (FIGURE 19).

FIGURE 19 Monograms for department stores Daimaru (left), Mitsukoshi (middle), and Takashimaya (right). *TCCA*, vol. 19, page 23, September 1929.

In a two-page spread featuring the Edo sampler discussed above (FIGURE 17), the facing page displays an early advertisement for designer Paul Renner's pioneering geometric sans serif type, Futura, released by the Frankfurt-based Bauer Type Foundry in 1927 (FIGURE 20). The German reads "the writing is the soul of each advertisement." This juxtaposition is a perfect representation of the lively coexistence of divergent lettering tendencies in modern Japan. Despite the widespread appeal in Japan of the new typography (much of which, in contrast to the European precedent, was rendered by hand for each individual project), expressive lettering design continued to flourish throughout the prewar period.

FIGURE 20 Advertisement for the Futura typeface, reproduced in *TCCA*, vol. 15, page 6, April 1930.

TEXT AND IMAGE

New experiments in typography were concerned not only with letterforms, but also with the critical relationship between text and image in editorial layout. *The Complete Commercial Artist* devoted half of volume 14 to photography, a significant new instrument for the development of commercial art.[41] One contributor, Kanamaru Shigene 金丸重嶺 (1900–1977), was a leading figure in photography criticism and education.[42] Japanese advertisements began to incorporate photography, or more precisely photogravure, starting around 1910. As in graphic works, beautiful women were the most popular early subjects. By the 1920s, commercial artists sought to incorporate photographs into their compositions because they purported to record the truth, lending advertisements an aura of reality.

According to Hamada, people trusted photographs more than any other medium; they were reliable and clear, two key components for promoting confidence in the consumer. A photograph, he noted, was the next best thing to presenting the commodity itself. In fact, it was better, because one could cleverly manipulate photographs to produce certain visual and emotional responses while maintaining the semblance of unmediated representation.[43] A few years later, in a series of articles written for the photography journal *Kōga* 光画, Hara Hiromu celebrated the new possibilities for integrating typography and photography, adopting Moholy-Nagy's term "typophoto" for this new visual field and finding common cause in the latter's claim that "the objectivity of photography liberates the receptive reader from the crutches of the author's personal idiosyncrasies and forces him into the formation of his own opinion."[44] Designers in the 1920s seized on the techniques of modernist photography for commercial (and political) purposes, experimenting with viewpoint, perspective, and scale, not to mention the use of extreme closeups and dramatic silhouettes and shadows. These provided advertisers with a vocabulary of decontextualized formalism and abstraction that communicated urbanity, cosmopolitanism, rationalism, and technological progress (FIGURE 21).

Experiments importantly included the creative fusing of disparate images and texts in photomontage. "By combining two or more images, by joining drawing and graphic shapes to the photograph, by adding a significant spot of color, or by adding a written text," observes photography curator Christopher Phillips, the designer could employ montage to "divert the photograph from what it 'naturally' seems to say" and "underscore the need for the viewer's active 'reading' of the image."[45] In the commercial arena, such techniques were employed to create

FIGURE 21. TOP Kaneko Hiroshi, creative advertising photograph, *TCCA*, vol. 14, page 6, August 1928. BOTTOM László Moholy-Nagy, "typophoto" cover design for *Broom* magazine (1922), reproduced in *TCCA*, vol. 14, page 19, August 1928.

FIGURE 22 Spread showing Arai Sen's original advertising photograph for soap (left) and a photo collage by Nakada Sadanosuke (right), *TCCA*, vol. 14, pages 4–5, August 1928.

nonlinear promotional narratives that metonymically linked the paired correlates of text and image—the product and its concept. The result provided a multiple, but still controlled, perspective that sought to sway the viewer-consumer through accumulated layers of meaning, always returning to the product and company identity.

In the Ars compendium, photomontages for commercial purposes abound. Group of Seven member Arai Sen 新井泉 (1902–1983), for instance, presents a humorous combination of women's faces and large typography to promote the fictitious Bigan (Beautiful Face) soap. The dynamic zigzagging layout of seemingly disparate photographic and textual fragments animates Arai's eye-catching composition, which intersperses dramatically cropped images of glamorous, exotic Western women from Hollywood movies with the product's brand name and the repeated English word "soap." The eye travels from the upper left corner across the page to the right, where it ricochets off the head of an attractive woman, whose enticing stare establishes direct eye contact with the viewer. The composition then reverses the viewer's gaze back to the left, and then jerks it once again to the right and down to the bottom of the page. The composite is somewhat tenuously anchored at the bottom by an image of the Little Rascals (of the comedy film series *Our Gang*), all clustered together staring intensely at a superimposed object labeled "soap," held in the grasp of the central figure (FIGURE 22, LEFT). Part of the appeal of this

image, and photomontage in general, is its incongruity. By reframing unrelated images through self-conscious coordination, it forces the viewer to reconsider the supposedly natural meaning of the image. Since this design mockup was merely a proposal and not an actual advertisement, its effectiveness in the marketplace cannot be gauged. But the increasing use of photomontage in Japanese commercial design throughout the 1930s attests to the popularity and, one can surmise, the efficacy of this form. Photomontage soon became the dominant visual idiom of the global 1930s and '40s.[46]

Similarly, advertising illustrations gained importance alongside developments in manga cartoons and hand-drawn illustrations or *katto*. The second half of volume 14, devoted to the popular cartoons that promoted many Japanese products, featured work by artists who explored new stylistic and narrative possibilities of the medium. Well-known cartoonist Maekawa Senpan 前川千帆 (1888–1960), for example, contributed two lively cartoons on advertising flyers for restaurants and cafés. The one on top shows a suited maître d' figure with a pronounced belly and animated facial features calling out to potential customers to come inside and try all the unusual things on the menu. Below that a salaryman and a modern couple are pictured on the outside of a coffee cup. Whether they're on their way home from work or at the end of a leisurely stroll, these customers will discover a "bright," "quiet," "pleasant," "relaxed," "tasteful," and "classy" place at this newly opened nearby café, vividly described by the animated text swirling around the cup (FIGURE 23). Cartoons were particularly effective for caricaturing new types of consumers and offering endearing, sometimes whimsical, representations of animals. Volume 16 was dedicated to hand-drawn illustrations, which were cost-effective and dominated advertising across print media and in logo designs. Such illustrations often focused on new cosmopolitan consumer types and heavily emphasized new leisure and sports activities for both men and women (FIGURE 24).

FIGURE 23 Maekawa Senpan, cartoon designs for restaurant and café advertisements, *TCCA*, vol. 14, page 33, August 1928.

FIGURE 24 Hara Mansuke, cartoon illustrations, *TCCA*, vol. 16, pages 30–31, June 1929.

EDITOR HAMADA MASUJI

Hamada Masuji, one of the most vocal design theorists of this period, had a major impact on the development of the modern Japanese design movement during its critical formative stage in the late 1920s and early 1930s. By publicly endorsing art as a means of persuasion and by systematizing the specialized knowledge designers needed to obtain, he helped launch a new professional field of artistic practice that explicitly and unapologetically put aesthetics in the service of commerce. For Hamada, products could not merely be placed in the market to speak for themselves. They required skillful packaging. And who better to design this packaging than artists, who understood the affectivity of visual stimuli?

Raised in Osaka, Hamada trained in fine art, first in Western-style painting at the White Horse Society (Hakubakai 白馬会) painting studio run by Kuroda Seiki and his students, and then at the academic Pacific Painting Society studio (Taiheiyō Gakai 太平洋画会). Subsequently, he entered the Tokyo School of Fine Arts' sculpture division. Like so many of his contemporaries, he began freelancing as a commercial designer while still in school. In 1926, he helped form the Commercial Artists Association.[47] Founding members of the association included Murota Kurazō 室田久良三 (a.k.a. 室田庫造; active circa 1920–circa 1966), editor of the soon-to-be-launched trade journal *Advertising World* (*Kōkokukai* 広告界); Tada Hokuu 多田北烏 (1889–1948), Sun Studio director and *The Complete Commercial Artist* contributor; and several members of the Group of Seven (FIGURE 25). Design

FIGURE 25 Detail of a page showing Group of Seven (Shichininsha) members at the organization's third poster exhibition, held at the Mitsukoshi department store in 1928 at left, and Commercial Artists Association (Shōgyō Bijutsuka Kyōkai) members at the organization's second exhibition, at the Tokyo Prefectural Museum in 1927 at right. From *Commercial Art Monthly* (*Shōgyō bijtusu geppō*), no. 1, June 1928, distributed with vol. 2 of *TCCA*, letterpress, 10¼ × 7½ inches (26 × 19 cm), Tokyo.

FIGURE 26 Murota Kurazō, cover for *Advertising World* (*Kōkokukai*), vol. 4, no. 1, January 1927, 10¼ × 7½ inches (26 × 19 cm), Tokyo.

historian Tajima Natsuko has surmised that they formed the association in consultation with *Advertising World* publisher Seibundō 誠文堂 as a think tank for starting the magazine; many of the members had already published with the journal's precursors and most became future contributors to it (FIGURE 26).[48] The association mounted yearly exhibitions starting in September 1926, mostly in fine art venues.[49] Many were sponsored by prominent newspapers and reviewed with great interest in both the arts media and the popular press. Critics referred to the group as "artists of the streets" because of their impact on the look of the urban environment.[50] Lettering designer Yajima Shūichi established a sibling group in Osaka in January 1928, inspired by both the association's work and the Group of Seven's second exhibition of posters, which traveled to Osaka in August 1927. The formation of chapters in Nagasaki, Sendai, Iwate, and Hiroshima followed.[51] The association then opened a study center in 1929.

That same year, however, right when *The Complete Commercial Artist* project was getting underway, Hamada and Tada Hokuu parted ways, with the latter forming the Association of Practical Print Arts (Jitsuyō Hanga Bijutsu Kyōkai 実用版画美術協会) with Okuyama Gihachirō 奥山儀八郎 (1907–1981) and the young prodigy Fujisawa Tatsuo 藤澤龍雄 (1893-1969).[52] Murota and Tomita Morizō 富田森三 (1901–?) had already distanced themselves from the association, ostensibly to concentrate on *Advertising World*. The defections indicated a simmering tension among these strong-willed and opinionated creative individuals, all of whom were jockeying for leadership. Hamada unabashedly assumed the association mantle, and in 1930 he launched the periodical *Commercial Art* (*Shōgyō bijutsu* 商業美術) with himself as editor. That June, the British trade journal *Commercial Art* prominently featured several of his design works in an article by critic Harada Jirō that described Hamada as the leader of the association, with a large number of followers, playing a role comparable to that of Sugiura and the Group of Seven in popularizing commercial art in Japan.[53] Three years later, Hamada established his own design school, the School of Commercial Art (Shōgyō Bijutsu Kōsei Juku), which offered a three-year program for certification as a commercial artist. All the while he continued to participate in many published roundtable discussions and to develop his opinions in a wide range of journals.[54]

Hamada articulated his most comprehensive expression of his theory of commercial art in the final volume of the Ars series, in a hundred-page essay titled "Introduction to Commercial Art," which explicated the theoretical underpinnings of commercial

design and the social implications of the field.[55] His design theory combined modernist fine art aesthetics with values associated with industrial progress: rationalism, efficiency, effectiveness, applicability, and pragmatism. To this he added a touch of popular psychology and visual perception theory, as well as a strong dose of Marxian social utopianism. By defining his own distinct brand of commercial art, Hamada influentially paved the way for both a commercialization of aesthetics and an aestheticization of commerce.[56] Hamada's essay framed the entire series project within the scope of his advocacy. While his view did not represent that of every contributor, he gave voice to the shared desire to promote the social status of commercial design in the realm of the visual arts and to legitimize its contributions to that field. Hamada's personality and views remained in tension with those of many of his colleagues, who had diverse attitudes toward their professional field, but his vociferous efforts as a champion remain an important legacy.

With modernism as his transformative tool of choice, Hamada argued that the visually evocative aesthetic strategies of autonomous abstract art could be redirected to serve a more clearly functional purpose. "Form itself," he wrote, "resonates with people in distinct ways," and it was the designer's job to maximize and direct this resonance in the mind of the consumer.[57] Hamada and his colleagues closely followed international developments in modernism and the avant-garde by reading publications, attending exhibitions, and traveling abroad. He developed these convictions, already evident in his didactic illustrations and essays in the first published volume of the series, through references to international developments in modernism (FIGURE 27). Adapting Le Corbusier's famous dictum that a house was "a machine for living in," Hamada produced his own mechanical metaphor, envisioning "art as a machine with a purpose."[58] The implication was that art could function pragmatically through applied design, which practitioners could manipulate in a manner akin to precisely calibrating a machine. Industrial development became the inspiration for Hamada's commercial art, its vigor supplying the designer's "energy."[59]

Hamada called commercial art "art with a purpose" (*mokuteki no bijutsu*), distinct from pure art or art for art's sake, produced for aesthetic appreciation and individual expression.[60] Indeed, his theory centered on the notion of purpose. How efficiently, effectively, pragmatically, and appropriately a work achieved its aim was the main criterion for evaluating its worth, while pure art was measured by the gauges of beauty and aesthetic pleasure. In *shōgyō bijutsu*, the new scientific credo of the

FIGURE 27 Hamada Masuji, formal study of expressive gesture in poster design, *TCCA*, vol. 2, page 10, June 1928. In his commentary about this study on page 70 of the same volume, Hamada writes, "Just as pure art concentrates on the search for beauty, in commercial art it is even more important that the quest for form proceeds from commercial necessity."

age, which arrived hand in hand with industrialism, found expression in a host of buzzwords, including rationalism (*gōri*), exactitude (*seikaku*), clarity (*meiryō*), and suitability to purpose (*gōmokuteki*). Hamada argued that this form of art addressed the real-life conditions of a modern industrial society under capitalism. It was less elitist than pure art, appealing to the mass consumer. Ultimately, he believed, the practical or applied arts would enable the artist to break through the limiting bonds of subjectivity in pure art.[61]

Heralding a new consciousness for design, he advocated the independence of the designer vis-à-vis the client's demands. He also insisted design should have a conceptual—and even social—underpinning that would function beyond purely monetary objectives. This conception of design signaled a new combination of the spiritual and the material. Design would transform a product into a commodity by mediating between the producer and the market, generating image and desire. Commercial art was, by this function, "that which went beyond pure purpose; it [was] what inspired love, attachment (*aichaku*)," enabling the "spiritual elevation of commerce."[62]

Hamada's commercial art tended to emphasize production, downplaying consumption as the "bourgeois" component of modern commerce. He claimed the "main purpose of commerce was to enhance the prosperity and livelihood of the masses." "Mass production," he wrote, "would solve problems by producing only practical, necessary items rather than consumer demand items."[63] Yet despite his claims to the contrary, fueling consumption was the essential flip side to Hamada's commercial art strategies. It was the implied and hoped-for consequence of his techniques. Moreover, developments in the consumer market fueled the expansion of the commercial design field as much as, if not more than, developments in production. This fundamental tension remained unreconciled in his writings.

Hamada also gave little serious attention to the issue of a product's merit or the designer's possible complicity in creating what some would call false need. Instead, he somewhat naively asserted the importance of sincerity when promoting a store and its products, warning simply that deception would be discovered. Repeating slogans such as "move away from profiteering and toward social meaning" throughout his text, Hamada relied heavily on the integrity of the producer and the designer to safeguard the interests of the consumer.[64] Yet it is undeniable that the very strategies Hamada championed were often effective precisely because they persuaded consumers to purchase items they might not necessarily need.

Bold color, dramatic composition, and innovative materials were just a few of the elements Hamada advocated as the means to make a product stand out, to accentuate its special features, and to attract the eye of the consumer. As the series of illustrations that begin his essay show, he drew upon the abstract formalist strategies of modernist and avant-garde art to produce visual "agitation" (*sendō*).[65] In each grouping is at least one piece labeled *shōgyō bijutsu*, demonstrating the easy conversion of modernist "isms" into styles for the commercial realm. One illustration shows a group of constructivist works. Alongside two Bauhaus material studies—fundamental exercises in the school's primary course, which served as a transitional stage between art and design—are works by Russian constructivists El Lissitzky and Natan Altman (FIGURE 28). Another nearby piece is identified as a show window display for a German stationery store (FIGURE 29). The surrounding works employ lively abstract compositions, dynamic asymmetry, projecting diagonals, strong contrast, and effective manipulation of materials. Juxtapositions of color, though not evident in the black-and-white reproductions here, feature prominently in the originals. The show window employs similar techniques. Even the German text—"What a headache/Why, why, why/Please use our instruments"—visually accentuates the composition with its off-kilter, perpendicular positioning in relation to the geometric forms.[66] The layering of square components that diminish in scale draws the eye down toward the right corner and to the goods displayed below. The books and writing implements lie on the platform and are inserted into the display.

FIGURE 28. TOP El Lissitzky; *Proun 17 N. (Aero Proun Aquarell)*; circa 1920; pencil, black ink, pen, gouache, and watercolor; 14⅜ × 10½ (36.5 × 26.5 cm); Moscow. BOTTOM Natan Altman; *Russia. Labor*; 1921; wood, enamel, oil, metal, charcoal, and graphite powder on wood; 38¾ × 19¼ inches (98.5 × 49 cm); Moscow. Both works are reproduced in *TCCA*, vol. 24, page 9. September 1930.

FIGURE 29 Unattributed show window for a German stationery store, from Hamada Masuji, "Introduction to Commercial Art," *TCCA*, vol. 24, page 9, September 1930.

——シュプレマチズムと其實用的方向——

(A) シュプレマチズム作家マレヴィチの作品(繪) (B) テ・オ・ヴァン・デアスブルグの同作品 (1917年) (C) 同・マレヴィチの作品(繪)
(D) 合理的構圖を示しためスターヘーの試案 濱田増治作(1927年商業美術展出品) (E) シュプレマチズムダイグミズの混合意識の內に形
村山知義作繪畫のさしたの造型 (F) 商業美術作品ピールポスター(圖案) 濱田増治作(1929年)

In another illustration, Hamada presents an array of abstract paintings (FIGURE 30). A and B are suprematist works by the Russian artist Kazimir Malevich that emphasize the primacy of feeling through abstract forms and compositions. C is by the De Stijl principal Theo van Doesburg. E is a collage construction created as an homage to van Doesburg by Japanese artist Murayama Tomoyoshi. And D and F are by Hamada himself. A caption identifies D as an experimental "rational composition" for use in a poster, with no product explicitly mentioned. F, in the right corner, is identified as a design for a beer poster. Mirroring van Doesburg's work to the left, Hamada produces a lively decorative backdrop that simultaneously camouflages and reveals the *katakana* letters ビール for "beer" looming above.[67] Immediately below one can make out the shape of a bottle with its label and roughly discern figures seated at tables in a café. The abstract composition subtly discloses its figurative content to the viewer, inviting a leap of imagination.

While Hamada's essay to some extent stands on its own as a personal statement of theory, a similar comparative approach to deriving design lessons from modern sources extends throughout *The Complete Commercial Artist*. For example, volumes 3 and 4 provide photographic surveys of show window displays from around the world, which are then followed by illustrations of prospective designs and actual examples of Japanese show windows, several experimenting with modernist design techniques. One photograph presents "new cinnamon felt hats" on sale at Maruzen 丸善. In the show window, the emphatic curve of the background echoes the rounded shape of the hat brim, connecting the display with the displayed. The use of only two hats and their geometric, architectonic shapes accords with the minimalist, structured form of the display. The tipped hat at bottom left playfully acknowledges the presence of the viewer (FIGURE 31). A second photograph shows a window advertising international newspapers and magazines, announcing a display of samples on the top floor of the store. The bold black grid of the central props structures the visual field of the windows, creating easily legible compartments for text and commodities. Color contrasts of black, white, and presumably primary colors accentuate this division.

The topic of display was central to *The Complete Commercial Artist*, with a total of nine volumes devoted to show windows, signboards, in-store display equipment, sales decorations, and display designs for exhibiting goods. Hamada drew inspiration from modernist art for even the most basic elements of platform design and props. In one illustration, he sets a photo of his own

FIGURE 30 Examples of "suprematism and directions for its practical application," in Hamada Masuji, "Introduction to Commercial Art," *TCCA*, vol. 24, page 6, September 1930. TOP LEFT (A) Kazimir Malevich, *Black Square*, 1915; TOP CENTER (B) Kazimir Malevich, lithograph from the album *Suprematism: 34 Drawings*, 1920; CENTER LEFT (C) Theo van Doesburg, *Composition IX, Opus 18: Abstract Version of Card Players*, 1917; TOP RIGHT (D) Hamada Masuji, "rational composition" for use in a poster; BOTTOM LEFT (E) Murayama Tomoyoshi, homage to van Doesburg; BOTTOM RIGHT (F) Hamada Masuji, design for a beer poster.

FIGURE 31 Examples of "background display props that harmonize the best with the presentation of letters." TOP "New cinnamon felt hats" on sale at Maruzen in Tokyo. BOTTOM Window advertising newspapers and magazines. *TCCA*, vol. 4, page 57, January 1929.

FIGURE 32 Examples illustrating "the road to commercial art in three-dimensional plastic arts form." TOP LEFT Georges Vantongerloo, *Construction of Volumetric Interrelationships Derived from the Inscribed Square and the Square Circumscribed by a Circle*, 1924. TOP RIGHT Hamada Masuji, window display. BOTTOM Kurt Schmidt with F. W. Bogler and Georg Teltscher, *The Mechanical Ballet*, 1923, detail. All reproduced in *TCCA*, vol. 24, page 12, September 1930.

plastic arts window display next to photos of sculptural works by De Stijl designer Georges Vantongerloo and a sculptural motif for a Bauhaus stage design by Kurt Schmidt and Georg Teltscher (FIGURE 32). The massing of volumetric forms on the show window's stage and the effective use of props for structuring space was a central concern. In fact, the art of the show window was likened by many, including Hamada, to theatrical stage design. Systematic studies and charts of various stepped-stage platform options and backdrop organization systems document extensive experimentation in this field (see page 99). Invaluable for pedagogic purposes, these diagrams and sketches also lent an air of scientific credibility to the subjective artistic endeavor of design, as if to imply that through methodical study absolute results could be guaranteed.

Together with a broad range of activist-designers, Hamada and his wide circle of colleagues spearheaded a movement to construct a new social status for design, legitimating commercial art as a significant area of artistic practice with the potential to promote social change through innovative forms and new functions. While Hamada, who died only eight years after finishing *The Complete Commercial Artist*, did not live to see the full fruition of his activism, he and his colleagues started a major artistic and social movement to professionalize advertising design, directly contributing to its establishment and success in the postwar period.

CONCLUSION

Advertising art in the 1920s and '30s was an art of the present but also one of the future. Keeping up with new technologies in the field was a critical endeavor for design publications. As playfully announced in a flyer for the series featuring a chicken laying new eggs and crowing "Complete Works of Modern Commercial Art" (FIGURE 33), *The Complete Commercial Artist* offered an invaluable tool for broadcasting this new information while also giving shape to a new conception of design. In arguing for the systematic application of visual art techniques in commercial design, this compendium successfully helped forge the new category of artistic production under the new label of *shōgyō bijutsu*, which infused art with a purpose and aestheticized commerce. The series publicized the names of individual designers generally engaged behind the scenes in this process. Seeking to influence consumers by visually manipulating their perception of goods, daily life, and even the urban environment, its editors and contributors portrayed commercial art as a means to affect social change through innovative forms and new functions (FIGURE 34).

This depiction marked a convergence of concerns between modern designers and fine artists around the world. Artists active in the modernist new art movement (*shinkō bijutsu undō* 新興美術運動) in Japan, as well as various avant-garde groups abroad, increasingly sought to incorporate a more productivist perspective into the realm of fine arts, aspiring to make their work more applicable to the conditions of daily life. At the same time, those in the commercial art sphere sought to aestheticize their production by applying modernist visual techniques to everyday design. The abundance of publications on various areas of design practice, the explosion of design study groups, and the establishment of educational programs in design, both as independent institutions and within fine art academies, greatly reinforced the importance of this area of artistic production in the Japanese art world. State support and interest in design also grew in this decade, reflected in the incorporation of a crafts section into the official annual salon sponsored by the Ministry of Education in 1927 and in designers' active participation in state initiatives ranging from clothing reform to propaganda production.

Looking through this encyclopedic visual time capsule, readers will quickly become immersed in the aesthetic concerns of Japanese designers navigating the multinodal world of design in the late 1920s. They will also gain new appreciation for the transnational circulation of design, seeing how creative

FIGURE 33 Unattributed advertisement for *The Complete Commercial Artist*, 1928, offset, 4½ × 6¾ inches (11.5 × 17.25 cm) folded, Tokyo. This design served as the cover page for a two-sided foldout flyer with extensive details about the series and a subscription on one side and a colorful poster on the other (see fig. 34).

practice boldly crossed national borders undaunted by cultural difference and geographical distance. In a sense, this richly illustrated book, and the compendium more generally, complicates and enhances our received understanding of design history as practiced around the world. While fitting within the larger history of Japanese design as a nascent precursor, *The Complete Commercial Artist* also confronts readers with a vision of the possibilities and the future of design from the vantage point of the 1920s that was much more entangled with the global in real time than conventionally thought. Ostensibly interrupted by the horrors of war, this vision in fact fed into sophisticated propaganda production that supported wartime mobilization, then later helped relaunch the postwar Japanese design world. From our own vantage point, we can look back with fresh eyes at this important time in Japanese design history as it set the groundwork for much commercial design practice up to the present.

FIGURE 34 Unattributed poster for *The Complete Commercial Artist*, 1928, offset, 18 × 13½ inches (46 × 34.5 cm) unfolded, Tokyo. Hand lettering and cartoons, possibly by Maekawa Senpan, tout the compendium's famed contributors, novelty, and usefulness, with promises it will produce "big smiles" and depictions of the volumes inspiring a student (bottom right), guiding an artist's hand (top center), and informing businessmen (bottom center and left, and top left). Samples including European posters and advertising poles, show window photographs, and a regrettable, but indicative of the times, blackface design for a Japanese signboard demonstrate the range of the compendium's contents.

ENDNOTES

[1] *Gendai shōgyō bijutsu zenshū* (*The Complete Commercial Artist*), ed. Kitahara Yoshio, vols. 1–24 (Tokyo: Ars, 1928–1930). Subsequent notes refer to this series as *TCCA*. The series has been reprinted in reduced size as *Gendai shōgyō bijutsu zenshū*, fukkokuban (Tokyo: Yumani Shobō, 2001). Price and distribution information is discussed in the reprint's supplementary explanatory volume. See Tajima Natsuko, "'Gendai shōgyō bijutsu zenshū' fukkoku ni yosete: Shōgyō bijutsu no kōryū to 'Gendai shōgyō bijutsu zenshū,'" *Bekkan: Kaisetsu, geppō, sōmokuji hoka, Gendai shōgyō bijutsu zenshū*, vol. 25, fukkokuban (Tokyo: Yumani Shobō, 2001), 23.

[2] Including the supplementary gazettes, 110 individuals contributed written works to the project, and the work of 172 individual designers was illustrated. Many contributors had connections to major department stores.

[3] The origins of the publisher Ars trace back to 1915, when Kitahara Tetsuo (1887–1957), whose older brother was renowned modern Japanese poet Kitahara Hakushū (1885–1942), founded the Oranda Bookstore (Oranda Shobō) and began publishing the arts magazine *Ars* (Latin for "arts"). Renamed Ars Publishing in 1918, the company produced literary and arts publications, including Hakushū's poetry collections and, starting in 1921, the popular monthly photography magazine *Kamera* (*Camera*). It also published popular lecture series on photography, art, and Western-style music. Kitahara Yoshio (1896–1985), the younger brother of Tetsuo and Hakushū, oversaw the publication of *TCCA*.

[4] All supplementary gazettes are reproduced in *Bekkan: Kaisetsu, geppō, sōmokuji hoka*, 31–128.

[5] The volumes were published in the following order: vol. 2 (June 1928), vol. 5 (July 1928), vol. 14 (August 1928), vol. 7 (September 1928), vol. 18 (November 1928), vol. 10 (December 1928), vol. 4 (January 1929), vol. 1 (February 1929), vol. 12 (April 1929), vol. 9 (May 1929), vol. 16 (June 1929), vol. 13 (August 1929), vol. 19 (September 1929), vol. 21 (November 1929), vol. 11 (December 1929), vol. 17 (February 1930), vol. 8 (March 1930), vol. 15 (April 1930), vol. 20 (May 1930), vol. 22 (June 1930), vol. 3 (June 1930), vol. 6 (July 1930), vol. 23 (August 1930), and vol. 24 (September 1930).

[6] At least thirty design compendia are known to have been published in Japan between 1912 and 1937. I am grateful to Professor Takahashi Tsugio of Kyoto Institute of Technology for sharing his compiled list.

[7] The same year the Ars compendium launched, Watanabe Soshū authored a book on modern Japanese industrial arts and crafts, *Gendai Nihon no kōgei bijutsu* (*Contemporary Japanese Crafts Art*) (Tokyo: Zuan Kōgeisha, 1928).

[8] Throughout this essay, Japanese surnames appear in front of given names.

[9] The acronym CAA appears as sample text in designs throughout *The Complete Commercial Artist*. See pages 171 and 370, bottom, of the present volume.

[10] Tajima Natsuko has collated a full list of authors broken down by total numbers of contributions and volumes in *Bekkan: Kaisetsu, geppō, sōmokuji hoka*, 131–33.

[11] Hamada Masuji, "Uridashi gaitō sōshoku no gainen to shōgyō bijutsu" ("The Concept of Street Sales Decorations and Commercial Art"), in *Uridashi gaitō sōshokushū* (*Street Sales Decorations*), *TCCA* 10 (1928): 4–5.

[12] Hamada Masuji, "Shōgyō bijutsu sōron" ("Introduction to Commercial Art"), *TCCA* 24 (September 1930): 15.

[13] Ibid.

[14] The association's original eleven members included Hamada Masuji, Ikegami Shigeo, Tomita Morizō, Hara Mansuke, Yoshida Shōichi, Tada Hokuu, Nakajima Shunkichi, Murota Kurazō, Yoshikawa Shōichi, Sugisaka Chinkichi, and Suyama Hiroshi. It also published the *Commercial Art Newspaper* (*Shōgyō bijutsu shinbun*) in 1931.

[15] See Jeremy Aynsley, *Graphic Design in Germany: 1890–1945* (Berkeley: University of California Press, 2000), 12.

[16] For a detailed discussion of the influential school curriculum, see Mori Hitoshi, "The 1930s of Tōkyō Kōtō Kōgei Gakkō," in *Shikaku no Shōwa 1930–1940*, ed. Matsudō Kyoiku Iinkai (Matsudō: Matsudō Kyoiku Iinkai, 1998), 23.

[17] Kawahata Naomichi, "Kokusaku senden ni okeru datsu shōgyō bijutsu no nagare," in *Shikaku no Shōwa*, 143.

[18] See, for example, "Advertising from All Quarters," *Commercial Art* 9.51 (September 1930): 130; "Modern Advertising in Japan," *Commercial Art* 11.66 (December 1931): 252–55. The latter article consists of captioned illustrations without additional text. Illustrated works include the covers of monthly catalogs produced by the Mitsukoshi department store in Osaka.

[19] H. K. Frenzel, "Joseph Bottlik: A Hungarian Poster Artist," *Gebrauchsgraphik* 5.4 (April 1928): 45.

[20] "Satomi Associates Science and Art," *Art and Industry* 27.161 (September 1939): 190–91. Satomi's work is discussed in Nakada Setsuko, *Kōkoku no naka no Nippon* (Tokyo: Daiyamondo-sha, 1993), 165–70.

[21] Eduard Wildhagen, "Reklame in Japan: Advertisements in Japan," *Gebrauchsgraphik* 4.5 (May 1927): 46, 48–49.

[22] Harada Jirō, "A Japanese Looks at His Country's Advertising," *Commercial Art* 8.48 (June 1930): 271.

[23] See Nakada Sadanosuke, "Kokuritsu Bauhausu (I)" ("National Bauhaus [I]"), *Mizue* 244 (June 1925): 2–7; "Kokuritsu Bauhausu (II)" ("National Bauhaus [II]"), *Mizue* 245 (July 1925): 8–12; "Bauhausu Goki" ("Bauhaus Postscript"), *Mizue* 248 (October 1925): 37–38; "Warutā Guropiusu Suisan" ("In Praise of Walter Gropius"), *Kenchiku shinchō* 6.10 (October 1925): 1–5; and "Bauhausu o kataru" ("Talking about the Bauhaus"), *Kōgei jidai* 2.1 (January 1927): 113–22. Avant-garde artist Murayama Tomoyoshi, leader of the Mavo group, was also instrumental in introducing the design theories of artists associated with the Bauhaus, particularly those of László Moholy-Nagy. See Murayama Tomoyoshi, *Kōseiha kenkyū* (*Study of Constructivism*) (Tokyo: Chūō Bijutsusha, 1926).

[24] Nakada's essays appeared in *TCCA* volumes 9, 14, 15, and 21.

[25] Paul Greenhalgh, introduction to *Modernism in Design*, ed. Greenhalgh (London: Reaktion Books, 1990), 2.

[26] See Greenhalgh, 5–22.

[27] Hamada, "Shōgyō bijutsu sōron," *TCCA* 24: 9, 32, 34.

[28] Ibid., 15.

[29] See Saga Kenritsu Bijutsukan, *Nihon kindai yōga no eiga: Okada Saburōsuke* (Saga: Saga Kenritsu Bijutsukan, 1993).

[30] See Sugiura Hisui, *Hisui kachō zuanshū* (*Complete Collection of Hisui's Bird and Flower Designs*) (Tokyo: Heiandō Shoten, 1917); *Hisui ippan ōyō zuanshū* (*Hisui's General Collection of Applied Design*) (Tokyo: Heiandō Shoten, 1921); and *Hisui hyakkafu* (*Hisui's Songs of a Hundred Flowers*) (Tokyo: Shunyōdō, 1922).

[31] *Affiches* published 14 issues total with print runs of 500 per issue: vol. 1, nos. 1–4 (July–October 1927); vol. 2, nos. 1–3 (October–December 1929); vol. 3, nos. 1–7 (January–March, May–June, August, and October 1930).

[32] For more information on Sugiura's career, see *Sugiura Hisui: Nihon modan dezain no kishu* (Tokyo: Tabako to Shio no Hakubutsukan, 1994).

[33] Sugiura Hisui, "Sōkan no kotoba," *Affiches* 1.1 (July 1927): 1.

[34] See David Pollack, *The Fracture of Meaning: Japan's Synthesis of China from the Eighth through the Eighteenth Centuries* (Princeton, NJ: Princeton University Press, 1986).

[35] Hara Hiromu, quoted in Matsuoka Seigō and Koga Hiroyuki, "Nihon no modan taipogurafi no hensen: Nani ga moji no dezain o odorasetekitaka," in *Nihon no taipogurafikku dezain: Moji wa damatte inai*, ed. Matsuoka Seigō, Tanaka Ikkō, and Asaba Katsumi (Tokyo: Toransuāto, 1999), 14.

[36] In the prewar period, a range of terms denoted design lettering, including *sōshoku moji* (decorative letters), *ishō moji* (design letters), *hentai moji* (anomalous letters), and *kōkoku moji* (advertising letters). See Kawahata Naomichi and Hirano Koga, *Kakimoji kō* (Tokyo: Dai Nippon Sukurīn Seizō, 2005), 10.

[37] Lettering compendia appeared as early as 1912, but the major boom in this kind of publication started in the 1920s. Twelve lettering design volumes were published between 1925 and 1928 alone. See Kawahata and Hirano, 16, 24.

[38] Takeda Gōichi, introduction to Yajima Shūichi, *Zuan moji taikan* (*Typographic Handbook*) (Tokyo: Shōbunkan, 1926), as quoted in *Japanese Modern: Graphic Design between the Wars*, ed. James Fraser, Steven Heller, and Seymour Chwast (San Francisco: Chronicle Books, 1996), 123.

[39] See Gennifer Weisenfeld, *Mavo: Japanese Artists and the Avant-Garde, 1905–1931* (Berkeley: University of California Press, 2002), chapter 5. Murayama Tomoyoshi's 1926 *Kōseiha kenkyū* was a landmark publication in Japan for articulating the philosophical principles of rationalized typography. In its editorial layout, the book formally instantiated the very principles it was describing, using a simplified Gothic-style typeface with geometric layout elements to order the text on the page.

[40] László Moholy-Nagy, "The New Typography," quoted in Murayama, *Kōseiha kenkyū*, 69; a translation of Moholy-Nagy's essay appears in *Looking Closer 3: Classic Writings on Graphic Design*, ed. Michael Bierut, Jessica Helfand, Steven Heller. (New York: Allworth, 1999), 21. Hamada discusses similar statements by Moholy-Nagy in "Shōgyō bijutsu sōron," *TCCA* 24: 87.

[41] For a discussion of advertising photography in Japan, see Nakai Kōichi, *Komasharu foto*, vol. 11, *Nihon shashin zenshū* (Tokyo: Shogakukan, 1986). Particularly noteworthy in this area is the work of Iizawa Kōtarō concerning the development of "new photography" (*shinkō shashin*) in Japan, its relationship to the Bauhaus in Germany, and its later impact on Japanese advertising; see, for example, "The Bauhaus and Shinkō Shashin," in *Bauhausu no shashin korokiumu* (Kawasaki: Kawasaki-shi Shimin Myūjiamu, 1997), 134–39.

[42] See *TCCA* 14: 14–21. Kanamaru Shigene taught photography at Nihon University for almost his entire professional career and was one of the most prominent names in Japanese photography criticism during this time.

[43] Hamada's essay in volume 14 further explicated the development of avant-garde photography techniques applied in German advertising design, including photomontage, photograms, and X-ray photographs. See Hamada Masuji, "Shashin oyobi manga ōyō kōkoku no gainen" ("Concepts of Advertisements with Photographs and Cartoons"), in *Shashin oyobi manga ōyō kōkokushū* (*Advertisements with Photography and Cartoons*), *TCCA* 14: 3–8.

44. Moholy-Nagy, "The New Typography," *Looking Closer 3*, 21–22. See also Moholy-Nagy, "Typophoto," *Looking Closer 3*, 24–46. For Hara Hiromu's essays, see "E-shashin, moji-katsuji, soshite typofoto" ("Painting-Photography, Letter-Typography, and Typofoto"), *Kōga* 2.2 (February 1933): 8–9; "E-shashin, moji-katsuji, soshite typofoto 2," *Kōga* 2.3 (March 1933): 29–36; "E-shashin, moji-katsuji, soshite typofoto 3," *Kōga* 2.4 (April 1933): 49–52; and "E-shashin, moji-katsuji, soshite typofoto 4," *Kōga* 2.5 (May 1933): 85–94.

45. Christopher Phillips, introduction to *Montage and Modern Life: 1919–1942*, ed. Matthew Teitelbaum (Cambridge, MA: MIT Press, 1992), 28.

46. For more on montage in this period, see *Montage and Modern Life, 1919–1942*.

47. The Commercial Artists Association also published the *Commercial Art Newspaper* (*Shōgyō bijutsu shinbun*) in 1931.

48. See Tajima Natsuko, "Senzenki Nihon no zuankai: Zuanka dantai Shichininsha to 'Afisshu' no sōkan," in *Afisshu = Affiches*, *Fukkokuban* Afisshu *bessatsu* (Tokyo: Kokusho Kankōkai, 2009), 91.

49. The first exhibition of 100 poster works was held September 12–18, 1926, in the Marubishi clothing store in the well-known Marunouchi Building (commonly abbreviated as Maru Biru). The second exhibition was held at the Tokyo Prefectural Museum, May 7–18, 1927, and included 138 works. It was followed by the publication of a 52-page exhibition catalog in August. Many Group of Seven members exhibited with the Commercial Artists Association. See Tajima, 91–92.

50. Hamada quotes various responses to the association's work and exhibitions that appeared in contemporary Japanese newspapers such as *Kokumin shinbun*, *Yamato shinbun*, *Yorozu chōhō*, *Nihon shinbun*, *Maiyū shinbun*, and *Minato shinbun*. All refer to the group's work as "art of the streets" (*gaitō bijutsu*), and one reporter writing for *Yorozu chōhō* notes that the group was calling for a comprehensive "artification of the daily life of the masses" (*taishū seikatsu no geijutsuka*) ("Shōgyō bijutsu sōron," *TCCA* 24: 10–11).

51. The Group of Seven's second exhibition traveled to the Osaka Mitsukoshi department store August 24–29, 1927, eliciting great excitement among the Kansai design community. Hamada dates the founding of the Osaka chapter to October 1927, while Tajima dates it to January 1928; see Hamada, "Shōgyō bijutsu sōron," *TCCA* 24: 12, and Tajima, 92–93. By April 1932, public exhibitions of commercial art (*shōgyō bijutsu-ten*), such as the one sponsored by the powerful newspaper *Tōkyō nichinichi shinbun*, were attracting over 1,900 submissions and accepting 169 for display first in Osaka (at the Daimaru department store) and then in Tokyo (at the Mitsukoshi department store) a month later.

52. The first Jitsuyō Hanga Bijutsu Kyōkai exhibition was held in December 1929 at the Ueno Matsuzakaya department store. See Fujisawa Tatsuo, "Zuan to jitsuyō bijutsu" ("Design and Practical Art"), *Kōkoku-kai* 9.8 (August 1932): 26–27.

53. See Harada Jirō, 266–67, 271.

54. The group continued to sponsor regular exhibitions of members' work into the late 1930s, collaborating with the Ministry of Education and the Ministry of Commerce and Industry to mount major national commercial art exhibitions such as the All Japan Commercial Art Exhibition (Zen Nihon Shōgyō Bijutsu-ten) in March 1937, held at the Tokyo Prefectural Museum. Sponsors: Nihon Shōgyō Bijutsu Kyōkai, Mombushō, and Shōkōshō. Judges: Hata Shōkichi and Miyashita Takao.

55. See pages 414–18 of the present book for a translation of the concluding section of Hamada's essay. In addition to producing the Ars compendium, Hamada wrote a two-volume set of textbooks, *Shōgyō bijutsu kyōhon* (*Textbooks for Commercial Art*), for would-be designers and published numerous texts explaining the conceptual elements of design in the early 1930s. His publications include: Hamada Masuji, *Shōgyō bijutsu kōsei genri* (*Composition Principles of Commercial Art*) (Tokyo: Kōyō Shoin, 1935); Hamada Masuji, *Shōgyō bijutsu kōza* (*Commercial Art Lectures*), 5 vols. (Tokyo: Atelier-sha, 1937–1938). Hamada also wrote regularly for the journal *Craft Age* (*Kōgei jidai*), which ran from December 1926 until October 1927.

56. See Hamada, "Shōgyō bijutsu sōron," *TCCA* 24: 62.

57. Ibid., 14.

58. Le Corbusier, *Towards a New Architecture*, trans. Frederick Etchells (New York: Dover, 1986), 4; Hamada, "Shōgyō bijutsu sōron," *TCCA* 24: 85.

59. Hamada, "Shōgyō bijutsu sōron," *TCCA* 24: 16.

60. Ibid., 27–29, 32, 50.

61. Ibid., 57–58.

62. Ibid., 70–71.

63. Ibid., 66.

64. Ibid., 74.

65. Ibid., 13.

66. The original text in German reads "Kopfzerbrechen/Warum, warum, warum/Verwenden Sie bitte unsere Hilfsmittel."

67. Hamada Masuji, "Sangyō geijutsu no seitō naru hatten no tame ni," *Affiches* 3.2 (February 1930): 39–41. Hamada's hypothetical compositions for storefronts, his display design for Lion Dentifrice, and this beer poster were all illustrated in Harada Jirō, 266–67, 271.

Selected Pages from Volumes 1–24

Numbering over 2,000 pages, with original designs by more than 170 named Japanese artists, articles by at least 100 authors (including those in *Commercial Art Monthly*, a gazette included with each volume), and thousands of designs reproduced from abroad, the twenty-four–volume *The Complete Commercial Artist* is one of the most comprehensive and up-to-date published design resources of its time, not only in Japan but globally. Produced under the guidance of a six-person editorial committee and the vision of editor Hamada Masuji, each installment forms its own rich collage of materials related to a distinct theme.

A handful of recurring elements brings structural and aesthetic coherence to the series. After a detailed table of contents complete with artist names, most volumes open with between one and four photographic reproductions, each printed in a three-color halftone process on a special smooth white paper (see, for example, pages 49, 61, 119, 159, and 407). The next section, which occupies a large share of some volumes, features labeled grids of black-and-white photographs. Occasionally printed in red, blue, and teal inks for variety, these images are often scaled and rotated to make the most of every page and arranged to encourage comparison (see pages 81–87). The main attraction in most of the volumes is their sections of color lithographs with new designs by Japanese commercial artists. Most feature bright, flat colors and simplified graphic forms, although shading, texture, and naturalistic coloring also appear. As a result of how these sections were printed, using unique inks on the front and back of each press sheet, their color palettes tend to repeat in alternating spreads, creating a rhythm and visual consistency that unites stylistically disparate work. Finally, sections of essays with minimal black-and-white illustrations occupy the back third of most volumes, supplementing the visual fireworks with commentary, historical context, and technical information.

In the following pages, representative selections from across the series accompany overviews of its themes and essential contents. In general, documentary images of non-Japanese work and essay pages have been excluded in favor of examples produced by Japanese designers for use in *The Complete Commercial Artist*. The present book's page dimensions exactly match those of the original; however, many reproductions have been scaled or rotated to provide a more complete and user-friendly experience.

The volumes appear in numerical order (although they were released out of order), and the sequence of pages corresponds as closely as possible to the original. An introduction for each volume lists its subtitle and date of release, as well as providing a short walk-through of its themes. While original page numbers have been left visible, all parenthetical references in these introductory texts correspond to the page numbers of the present book. (In the original volumes, the page numbers restart in each new section, resulting in multiple pages with the same number within the same volume.) In keeping with traditional Japanese publishing practices, in which the text usually reads vertically from right to left (*tategaki*), the original volumes of *The Complete Commercial Artist* were printed to open with the spine facing right. Here, to align with modern *yokogaki*, in which text reads horizontally from left to right, as well as to be easily navigable for English readers, the volumes' pages have been arranged to open with the spine facing left.

As a whole, *The Complete Commercial Artist* offers contemporary readers a nearly encyclopedic view of commercial art practices during this important and pioneering time of artistic experimentation. Access to these reproductions opens an invaluable window into the historical emergence of Japan's professional design world within a far-reaching global network of practitioners, providing an up-close view of how it defined the field for future generations.

世界各国ポスター集

1

Posters from All Over the World
Sekai kakkoku posutā-shū

PUBLISHED FEBRUARY 1929
8ᵀᴴ RELEASE IN THE SERIES

This volume greets readers with a striking art nouveau poster of French actress Sarah Bernhardt as Medea, clutching a long sword, with bodies piled at her feet (opposite page). Vibrantly illustrated, the volume serves as a stunning reference on poster design in Europe and the United States, one that indicates Japanese designers' broad and deep knowledge of global artistic developments.

The examples gathered here illustrate a wide assortment of themes for posters, giving particular emphasis to theatrical entertainment and tourism. Stylistically, the volume also surveys a variety of major modernist movements, including art nouveau, Jugendstil, the School of Paris, expressionism, and international constructivism. It spotlights popular groups like Germany's Die Sechs (The Six), featured in an array of promotions for their own poster design services (page 50), as well as work for Parisian revues by well-known French poster masters such as Jules Chéret (page 51, top, upper right) and Henri de Toulouse-Lautrec (page 51, bottom right, upper left). Meanwhile, the racialized and stereotyped depictions of *La revue nègre* show the dominant primitivizing trends in modernist art and design that traveled around the globe (page 53, top right). Some poster examples extend into fantastic and experimental territory, playing with the plastic malleability of the human figure (page 52, bottom, lower right) and exploring the dynamic experiments of the new typography movement, freshly emergent in the 1920s (pages 58–59).

In the essay toward the back of the volume, the editors discuss Japanese advertising designs in this world context, starting with Edo-period posters for the Kabuki theater and including modern travel posters for new leisure destinations like the Japanese Alps. Overviews of poster design in both continental Europe and Japan include a reference list of poster designers (all men, reflecting the pervasive gender discrimination in the field at the time), complete with biographies and portrait photos. Lead editor Hamada Masuji discusses the genesis of the poster as a means of publicity and highlights the medium's special features, while brief commentaries on each country's signature posters explore the development of various national styles.

フランスの劇場ポスター
作 ア・ミュシャ

ドイツ六人社のポスター一タス
(A) グラース作　(B) ベイ作　(C) オツトラー作　(D) エシエレ作　(E) チエタラ作　(F) パルチンガー作

POSTERS FROM ALL OVER THE WORLD

世界各国ポスター集

(A・イギリス 作 B・ドイツ 作 C・イギリス-カウフアー 作 D・カツサンドル 作)

現代ドイツのポスター一

(A・ブッフス 作 1920年　B・ツツ リシャヤスカ 作 1920○)
(C・マエツェル 作 1920年　D・ハヨハンセン 作 1920年)

現代ドイツのポスター (A・ゾンネ 作 一九一九年　B・デロヤドル 作 一九二〇年　C・ヘルドスル 作 一九一八年　D・ボエツクマシ 作 一九一八年)

現代ポスタアイヅ一クロン作

B 10. DEUTSCHES Sängerbundesfest
HAUPTFESTTAGE 19.-22. JULI WIEN 1928

A assuh NUR FÜR KENNER
ADLER-COMPAGNIE A.G.
ZIGARETTE

(作=ダッシュ ーリュスーナ・B 作=ユパ ツイド・A) ータスポローリュスーナ反ツイド代現

実用ポスター図案集

2

Practical Poster Designs
Jitsuyō posutā zuanshū

PUBLISHED JUNE 1928
1ST RELEASE IN THE SERIES

In contrast to the first volume's focus on European posters, here we find mostly contemporary work by Japanese designers, presented in full color. Readers may imaginatively insert their products and stores into a panoply of sample posters featuring artful typography with placeholder names such as ABC. These practical designs employ a variety of styles for enticing consumers, putting global design knowledge at local fingertips. They capture moods ranging from the vibrant and fantastical in Sugiura Hisui's mermaid promoting an international aquarium (page 64) to the humorous in a film poster depicting the modern family as finger puppet characters (page 66, top right).

These designs call out to new consumer types, functioning as barometers of Japan's changing commercial landscape. Dandified modern boys (*mobo*) strut through the pages with stylish suits, boater hats, and walking canes (pages 66, bottom left, and 71, top right). The modern girl (*moga*), who bobs her hair and wears flapper dresses to sip cocktails and smoke at dance halls, promotes shopping in a design where she nonchalantly dangles a cat from her arm as an accessory (page 69). Assorted modern couples also debut on the advertising stage, with the new white-collar salaryman (*sararīman*) walking arm-in-arm with Japan's fashionable new woman (*atarashii onna*) in her trendy kimono, shawl, and upswept hairstyle (page 74). Images of beautiful women (*bijinga*) in kimonos or Western-style clothing were hardly new in Japanese advertising, but by the 1920s they were pictured in different ways and in novel establishments for modern women (page 66, top left and lower right). Posters also engaged children and their parents with playful images of animals—elephants brushing their teeth and zebras giving rides at animal-themed expositions (pages 70 and 78).

The volume's essays supply information about the technological and visual strategies of poster production, commentary on the nature of posters in modern society, and a walkthrough of featured designs. The expanding variety of poster formats and uses is evident throughout the volume. An opening image with designs mounted on metal rods includes examples of the popular triangular flag, including ones promoting the Mitsukoshi department store and Lion toothpaste (opposite page, top left and top right). A later assemblage of photographs (pages 62–63) illustrates posters in cafés, train cars, and even a bookstore displaying publicity for the design compendium itself (page 63, bottom left).

ポスター一としてしたつ趣向五種

(A) 紙のとり方を経済的に考慮して作れる髪形ポスター。
河目悌二案

(B) 葉書さし式に立案された物、中味を取り去つてもポスターの役目をする。
濱田増治案

(C) 立体的に實物を組合せて作れる立体ポスター（説明本文参照）
河合　間案

(D) 紙のとり方を経済的に考慮した三角ポスター
原　萬助案

(E) 紙のとり方を経済的に考慮して一枚々々はぎとりの出來るカレンダーを取りつけたもの。
濱田増治案

D

E

F

A　カフェー
B　電車内
C　書籍店
D　停車場
E　酒店
F　浴場

A

B

C

日本に於けるポスター掲出の類例

國際海洋博覽會

杉浦非水 作　　　　　　　　　　　　　　　　博覽會ポスター

ポスター・スタンプ八種 （A化粧品店 B洋品店 C小間物店 D喫茶店 E呉服店 F書籍店 G玩具店 H百貨店） 松原惟章 作

ラヂオ用 眞空管

tom

作 義知山村

婦人手藝品店

作 浩 山須

婦人手藝品のポスター一（藝術的泉氣のあるユーモア作例）

ハミガキとハブラシ

小畑六平 作

（商品をよく説明せんとするポスター）（軍色で力強い印象を象ぐへスターな作例）

建主を題とせるポスター一　(新築落成すにめたら作られるスポター作例)

藏田周忠作

営業堅実
信用無限

安全銀行

作祝　林

（銀行のポスター　銀行の業務を暗示せるポスター）

展望の連山・槍・穂高・焼・乗鞍・木曽御嶽・伊那駒・甲斐駒・地蔵・鳳凰・白根三山・赤石・富士・八ヶ岳・四季の行楽・新緑・避暑・紅葉・スキー

新様式の設備と待遇
千山閣
中央線下諏訪功塩尻諏訪駅下車野塩尻峠上

貯金!!!

毒日毎をつやすぬかすら
こんな咲いたいのてすて

作 清 井 藤 貯金奨勵のポスター一

宣傳用のポスター（上部白地の中の日的文字を入れる）

財團法人 ××× 校会

久保吉郎作

珍らしい動物博覧會

集楽園

作 多田北烏

子供を主題にしたポスター（ポスターの十一ヶ月二十二ヶ月內四月　遊園地博覽會等に向くポスターの一例）

3

世界模範ショーウヰンドー集

World Model Show Windows
Sekai mohan shō uindō-shū

PUBLISHED JUNE 1930
21ST RELEASE IN THE SERIES

This volume is a survey of storefronts and show windows from outside Japan, featuring mostly black-and-white in situ photographs. It sets the global scene for later issues devoted to local work by Japanese designers. The reader enters the designed cityscape with a zoomed-out macro view that spotlights whole buildings as commercial emporia (opposite page). The camera then takes us to the doorsteps of individual establishments to admire all manner of decorative signage (pages 82–83). Finally, we peer into a host of show windows—outside display windows in which stores exhibited merchandise—to see commodities onstage, framed within carefully designed views (pages 84–87).

As presented in the series, show windows offer a glimpse into the soul of the modern consumer city—a montage of modern life. They are tantalizing and inviting visual gateways to new cosmopolitan experiences. Their vibrant compositions radiate in all directions, with theatrical vortices that charge commodities with excitement (pages 86–87). These dynamic diagonals and gracefully arching lines often create evocative stage sets in tandem with mannequins, such as a sophisticated figure appearing to consider a selection of women's shoes (page 87, bottom). German constructivist-style window designs promote the new communicative possibilities of Telefunken radios, as well as assembly line arrangements of Gilka brand liqueur (page 84). Exaggerated and monumentalized numerals and letters draw the viewer's eye into the stage spaces of displays for products ranging from Kodak film to men's dress shirts (page 85). Throughout, an array of geometric and machinic shapes underscores the aesthetics of industry and the promise of material abundance through repetition. The displays transform pedestrians into flaneurs, studied observers of an urban commercial landscape, and choreograph the goods to produce enticing visual patterns. The customers can see themselves inserted into these stage settings as characters who implicitly connect the consuming body with its desired products.

The accompanying essays in this volume explain the visual and sensory affordances of the modern show window across the world, identifying important shops, describing how different countries cultivate national styles of display, and giving special notice to how leading retailers in the United States were setting global marketing trends.

世界著名百貨店概觀

A. グエルトルイム百貨店(ベルリン)　B. J. M アダムスム鷹店(ハンブロー)　C. ヘルマンルーテー百貨店(ベルリン)　D. フレデリクローヤー商店(ブリツセル)

世界著名百貨店概觀

A. ルドルフカルスタット A.G.(ハンブルグ)　B. リモルサー百貨店(チューリヒ)　C. ゼーソンフーン百貨店(アムステルダム)　D. レーイメ(マンチエスタ)

各國陳列窓造形態樣範例 (14) (15)

(14) A パラヴァン設計　窓を突き出し用して内部を張し出し用した装飾窓
(15) B セイヴォードラウス設計　陳列窓の装飾を背景的装飾とした

各國陳列窓造形態樣範例 (12) (13)

(12) A ロージェロームド設計　窓のその背景を悪じさせる明るしに艶典
(13) B スキャニ設計　窓の装飾あたりとも時代感覚的造機機趣

各國陳列窓造形態樣範例 (22) (23)

(22) A ロベール G 設計　曲線のスペース調節、窓を上装飾を現出たし義に利機の品小
(23) B ロマーフレーヌ設計　窓陳列るだし陳陳し好も素物の表現とする側の内迫と利機の品

各國陳列窓造形態樣範例 (20) (21)

(20) A ボヴェースサーマを利陳の装絵をつもてしに式装造巻
(21) B デレエナタ設計　窓利国の窓形型造的飾或構

各國陳列窓構造形態範例 (40) (41)

(40) A. 小窓を多く持つた器具店マロニキアーユーリンアデザイン設計　(41) B. 出窓式に作られた玩具店　エツリアクーパゲーエ設計

(上)(下) バルクフアイストテ裝置 (ドイツ)　　構成的陳列の二例

印象的な構成陳列

主さとして数字の強調　（上）コダック社の窓　（下）オースチンシヨールーの陳列

異常的刺戟載によるに印象的な陳列窓

（上）　スイラルス商店　シェーベーエの作　（下）　クレフエルトにおける商店　エルスンストデユフエルの裝罝

表現派的印象を示した陳列二例

(上) 商品によつて形成されたる力強き構成 フリツクスハイム作　　(下) 背景の材料によつて作られたる力強き構図 ワルテルゲーリツケ作

4

各種ショーウヰンドー装置集

Various Equipment for Show Windows

Kakushu shō uindō sōchishū

PUBLISHED JANUARY 1929
7ᵀᴴ RELEASE IN THE SERIES

How does one design a show window or build a commodity display? What are the formal tools at the designer's disposal? This volume, dedicated to all the ways contemporary commercial artists could produce evocative show windows, explores the mechanics of display and breaks down a host of Japanese examples into constituent elements to demonstrate how each is effectively deployed.

The volume opens with photographs of a variety of show windows from around the world spotlighting everything from current women's fashions—East and West—to stationery products (opposite page). Then come pages of original colorful mockups for imagined commodities.

Some are simple and humorous, like a large smiling moon mischievously eating candy, designed to draw in children (page 93, top). Others are more elegant and oriented toward the machine age, using decorative patterns and arabesques (pages 95–96) or gleaming glass and metal surfaces (page 94, top) to convey a sophisticated consumer environment.

These window displays form a complex mosaic of parts that can be combined and recombined. Their elements include stands with varied shelving, dynamic backdrops, naturalistic and abstract decorative motifs, materials such as glass and electric lighting, and lifelike mannequins (opposite page, bottom). Diagrams toward the back of the volume demystify various show window promotional spaces, revealing their construction and relative proportions (page 99).

Seasonality and the evolving schedule of annual activities or *nenjū gyōji* that has structured daily life in Japan for centuries appear as drivers of design innovation throughout *The Complete Commercial Artist*. The series contains nods to the standard seasonal celebrations, as well as special festivities such as Boys' Day (*Tango no Sekku* or *Kodomo no Hi*) and Girls' Day (*Hinamatsuri*). In this volume, one display diagram celebrates the latter event with shelves filled with decorative dolls dressed like imperial aristocrats (page 99, top). Such commercial works capitalize on cultural attitudes tying seasonal changes to enduring motifs, as well as to poetic and affective themes. Similar motives account for the appearance of the traditional *noshi* motif, a folded paper ornament that signals auspicious and celebratory occasions (page 98, top).

多数商品の陳列整正とショーカードの巧みな配列装置四種

各種マヌカンの様式實例

北川隆三案

背景を主にたるお菓子店の装置

北川隆三 案

陳列台と背景を兼ねたる果物店の装置

濱田増治案

貴金屬の陳列に對す背景及びスタンドの裝置

(A) ユーモアを含む子供向き菓子店の背景装置
(B) 感情に訴えるとんと飲料の詩的背景装置

北川隆三案

電燈照明ある建築的構成の家具食器類の背景の装置　　　　　　　　　　　　　　　　　　　　　　濱田増治案

抒情的氣分を以て訴へとんするモダーンシーク向人婦の築地織品等の陳列装置　　　　　　　　　　　　　　　　中里研三案

背景と陳列台の構成及装置　　　　　　　　　　　　　北川隆三案

商品のみにて作られる陳列装置　　　　　　　　　　　中里研三案

濱田増治案　　　（初夏麦稈帽の賣出し）背景とスタンドを象ねたユーモラスな陳列裝置

季節を主題とせる果物店の背景装置置

北川隆三案

子供向き商品の陳列台と背景装置置

北川隆三案

中里研三案

前衛的に端てしへ訴的にすとんを特賣式の装置

中里研三案

特價的に端てしへ訴るたしをんと吳張組合せの類を陳列裝置

三月節句式段雛陳列装置の構造圖解

各種ショーウヰンドー背景集

5

Various Backgrounds for Show Windows
Kakushu shō uindō haikeishū

PUBLISHED JULY 1928
2ND RELEASE IN THE SERIES

Background imagery for show windows provides both narrative and decorative contexts for three-dimensional displays of goods. The examples and essays in this volume go into exquisite detail about how to create visually effective backdrops for fashions and goods highlighted in window displays. They also offer a few examples of show cards, small hand-lettered signs placed in shop windows to promote the various products on display (page 117), which had become a staple of merchandising in the late nineteenth century.

Overall, these background designs produce the sense of a theatrical stage set. They establish a commodity mise-en-scène using frames, curtains, borders, winding arabesques, and an array of decorative motifs with designated white spaces for product placement. Some of the images shown here suggest recognizable landscape or interior settings (page 102, top). Others feature ornamental patterns, with and without recognizable figures (opposite page). Regardless, window backgrounds seek to evoke powerful psychological reactions on the part of viewers, piquing their interest and spurring their consumption activities.

As seen in this volume's examples, some background designs conjure up entire urban cityscapes with bridges and trains (page 107), while others depict pastoral landscapes inhabited by magical creatures (page 106). An image of a hand holding aloft a delicate bird against a background of plum blossoms lends itself to promoting goods for spring sales, with the limb's strong shadow hinting at the dramatic potential of the new special lighting effects that were popular in such displays (page 103, top right). Designers also use bright colors and large motifs, including an oversize clock with numbers crossed out to indicate that time is running out to attend the final weeks of a sale (page 114, top left). In some cases, they create engaging patterns and dynamic shapes to focus the eye and draw it across the display (page 115).

Human and animal figures of all types abound in this volume. Again, we see the dapper modern Japanese boy appear as a guide to the commodity emporium, his black suit and hat a signifier of cosmopolitanism (page 105, top right), while graphical representations of the twelve animal signs of the Chinese zodiac offer decorative options for celebrations of the Lunar New Year (pages 108–9).

HAPPY NEW YEAR

(A)

(B)

(A) 鹿島光夫 作
(B) 濱田増治 作

正月の背景・A、百貨店其他大商店向正月の背景。B、中商店以下小さき窓に適するす正月の背景）

背景資料など ベるき舞台装置四種 （アドルフ・マーシェンク作）

最近日本の商店のウヰンドー背景四種
(A) 東京丸善　(B) 大阪高島屋　(C) 大阪三越　(D) 大阪高島屋

VARIOUS BACKGROUNDS FOR SHOW WINDOWS

VOLUME 5

各種ショーウヰンドー背景集

四 月 の 背 景 (女性向き陳列窓の品陳列面方面用廣し。吳服店物小同店化粧品店等)　　　上野正之助 作

五 月 の 背 景 (A・初夏のや軽かなかき氣分をいとして楽器店香料店等に向き背景と利用古)　　　北川隆三 作
(B・文房具店向き小さきウインドーの背景と其裝飾)

八月の背景 （A・洋品装身具其他カイラ向き商店用。B・応用各方面最も手軽に出来る背景小景）

金山新六 作

原萬助 作

九月の背景 （女性向きと男性向きのサロンードン背景。応用各商店）

作 荒 光 三 春

(書背む因：野山の林でしまを分泉行数)　裏背の月一十

作 二 悌 目 河　　　　　　　　　　　　　　　　(二)科資案圖の支二十きべるす用利に景背―ドンキウーヨシ

作 二目鶴河　　　(一)料資案圖の支二十きべるさ用利に景背ードンヰウーョシ

（（向に等伝宣景背及店書器樂店品用兒童品）） 景背之的表裳童

34

作都匠意屋松

（景背な的書書きべろま用應に等店籍書店器樂店用品兒店員長稅） 景背のードンキウな的話童

35

作 雄 武 井 武

宮下孝雄作　　　　　　　　　商品をよく目立たしめる背景の式スタンド

（外國資料より）　　　　　　　　　　　　　　　　　　　　　　　　　　　　　　　　　　　（描畫式の水邊消涼の背景）　夏のウキンドーの背景

小さなウヰンドー背景 （夏のウヰンドー背景 子供を主としたる商店向き）

秋吉秀雄作

特賣週間を強調せるウヰンドウ背景 （A・均一特賣のウヰンドウ背景。B・懸賞付限定特賣のウヰンドウ背景）　　　　　　　山 中 民 一 作

所装飾のウヰンドウ背景二種　（A・立体的な力強さを持つ背景。B・立体的な情景）　　　　　　　　　　　　　　　　　作　神 原 久 末
　　　作　木 村 裕

大都會の情趣を取題たしに百貨店の背景裝置　　　　　　　　　　　　　　　松屋意匠部作

リズミカルなる表現の背景（主として畫品の單色を品々に用てしるふ背景）　　　　　　　　　　濱田增治作

SHOWCARD DESIGNS

TOKKA HIN

世界各国看板集

Signboards from All Over the World
Sekai kakkoku kanbanshū

PUBLISHED JULY 1930
22ND RELEASE IN THE SERIES

Signboards (*kanban*) on buildings have been the bread and butter of commercial advertising around the world for centuries. This was no less true in Japan and in countries across East Asia, where many enticing examples of signage represented different trades and goods. As the first images of Chinese signboards in this volume show, they were often shaped into objects associated with the business, such as gourds for selling medicinal vinegar (opposite page, top right).

This volume establishes a broad international context mostly using black-and-white in situ photographs and illustrations of shop signs from around the world, with examples ranging from a simple pediment emblazoned with the word "Bar" to elaborately conceived motifs and names running horizontally and vertically across the facades of buildings (pages 122–23). With both regular and standardized sign typography and examples that are more dynamically expressive and oversize in scale, these marquees animate the building facades in different languages from around the world.

Many of these modern signs beam their identities in electric or neon lights, inherently symbolizing modernity and the artificial extension of the day that such illumination afforded (page 124, top). On a theater billboard advertising director Fritz Lang's 1928 thriller, *Spione*, the pupil of a giant eyeball shines like a searchlight or a movie projector (page 125, bottom).

Entire buildings can also serve as single signboards, as in Russian facades that draw the viewer's eye upward with towers and decorative fenestration (pages 126–27). At a less grandiose scale, standing signboards appear on independent kiosks or columns installed on the streets to intercept pedestrians (page 120, bottom). Advertisers also post signboards on mobile forms of transportation such as wagons, buses, trucks, and streetcars (page 121).

This volume gathers global examples from both continental Europe and the decorated signage of East Asia, where large *kanji* characters—plastered as publicity across buildings and decorated arches, and over time increasingly illuminated at night with electricity—served as heraldic gateways (pages 128–29).

(A) 醸造業 (醤油幌)
(B) 誕生日贈物店 (奉桃幌)

(1) 支那の看板

(A) 音楽居芝器店 (音楽工幌)
(B) 百貨店 (百貨舗幌)

(2) 支那の看板

各國看板揭出狀景
カリメア (B)　ユヴュンラーム裏ンリパ (A)

各國看板揭出狀景
(A) ロンドンの間道廣告はずカ (B) ロカヂ，ビーサミータリ際ケ在る大風のをの石 (イギリスロンドン)

各國看板種々相
(A) ドイツアドマアの驚　(B) ドイツアア業廣告に歸特寺觀等
「ドイツ日本見の市」型警察 (C)

各國看板種々相
(ドイツー開出廣告警察各種)

各國看板種々相
(車輛に施された廣告的趣向)
(A) オノトペンの廣告自動車　(B) スーツケースの廣告自動車　(C) ビスケットの廣告自動車

各國看板種々相
(建築全面的に施された看板文字)
(A)染物屋　(B)酒屋

各國看板種々相
(店舗入口に施された看板文字)
(A)玩具店ネオンを用ひたるもの　(B)織物店木製影刻式のもの

各國種々看板相
（軒上的象徴的装置に裝したる看板）
(A) 寶石店ダイアドの装飾　(B) 香料店ヴェイルのサンボス及びブレート設計

各國種々看板相
（裝飾的な店舖表面の看板形式）
(A) ジャドア美術品店（フランス）　(B) キャンガニカー（フランス）

各國看板種々相
活動寫眞館に假裝されたる看板（ドイツ）

各國看板種々相

活動寫眞館に假裝された看板（ドイツ）

各國看板種々相
（ロシヤの建築・工場と博覧會揭設館それにも試みられた的假看板施工）

各國看板種々相
(新興ロシヤの建築と看板)

第九圖 壁全面に盡かれたる看板文字

第十圖 壁に書かれたる看板文字

第七圖 北平の牌樓

第八圖 北平新新公司の大賣出し

実用看板意匠集

7

Designs for Practical Signboards

Jitsuyō kanban ishōshū

PUBLISHED SEPTEMBER 1928
4ᵀᴴ RELEASE IN THE SERIES

Expanding on the previous volume, this installment analyzes the significance of the longstanding signboard tradition in Japan while demonstrating how artists continued to update their designs, imbuing them with contemporary aesthetic tastes, inserting new commodities, and injecting innovative technology to spectacularize their visual impact. The term "practical" (*jitsuyō*) in the title again signals to readers that this volume provides a wealth of applied design templates for direct adoption.

At the beginning of the volume, an overflowing layout presents examples of premodern signage in a detailed graphic documentary style (opposite page). This illustrative motif was associated with well-known design professor Kon Wajirō, a self-proclaimed ethnographer of modernity who visually charted Japan's urbanizing and Westernizing daily life. Many of these signs are shaped like the goods they purvey (such as combs), while others take the shapes of paper lanterns, particularly the rounded and oblong *chochin*, which had been ubiquitous for centuries.

A later group of illustrated templates for hanging signboards puckishly inserts the name of the series' publisher, Ars, and that of its sibling firm, Atelier (an art publisher run by the same family), offering suggestions for "Ars Toothpaste" and "Atelier Ink" (page 133, bottom left and top right). Many of the sample letterforms verge on the illegibly ornate—for example, in colorful signage that travels vertically up buildings, illuminated by modern electricity instead of the traditional candle (page 134). One array of designs borrows its style from children's illustrations to provide enchanted motifs and fairytale faces, publicizing modern coffee shops such as the Mountain Café and Mask Café (page 137, center left and bottom right).

Multilingual examples are peppered throughout the volume. One page displays a giant "WC" glossed in Japanese below as *benjo* (bathroom), also includes wayfinders such as a sign for an entrance (*iriguchi*) at lower right and placards for posting orientation maps (*chizu*) in famous places (*meisho*) at upper left, all to help the new leisure class of travelers (page 140).

Store signs range across every commercial enterprise, from radio to popular fruit parlors that served tasty modern desserts (page 143). Some signboards are mounted on buildings (pages 134, 139, and 143, top); others stand on independent pillars, many with hands and arrows pointing to nearby stores (page 142, bottom); and still others appear on vehicles, particularly decorated trucks simultaneously used for delivery and for mobile publicity (page 142, top).

131

DESIGNS FOR PRACTICAL SIGNBOARDS

VOLUME 7

実用看板意匠集

電柱看板四種　　　　　　　　　　　　作畫惟原松

（図案説明）　福二匠意匠看板型造し出きつ用應気電

濱田増治案

カフェー屋上の看板意匠三種　　　　　　　　初山　滋　作

柏屋文具店 KASHIWAYA

照明装置断面略図

つき出し造型看板（照明装置を彼れるもの）

野口柾夫作

DESIGNS FOR PRACTICAL SIGNBOARDS

VOLUME 7

実用看板意匠集

作義知山村

自動車に施せる看板意匠

SYMBOL POLES

"代へて種々の店に"

河合間作

函柱な式坂看造型意匠三種 (A)がねめ (B)食料品店 (C)お子様の店

アカネヤ RADIO

つき出し電燈装置看板（うなぎ屋）　　　　　　　　　　野口柾夫 作

フルーツパーラー

果物店屋上看板圖案　　　　　　　　　　村瀬美樹 作

35

中亞各国 ★ 美術染織品陳列会

L'ORIENT

会期 皇会九月一十日 ★ 於 ロリアン百貨店楼上

S.OUYENO

東邦絨緞商
ペルシヤ店

S.OUYENO

上野之正助作　　　洋式な織物店の屋上看板意匠二種

つきだし小看板意匠三種 河合間作

作雄重上池　　　　　　　　　　　　　　　種二匠意板看の用應氣電

清涼 飲料

カクテル

SEIRYO-BIMI

HIDE・KISY

岸秀雄作　　　野立看板意匠二種

杉浦非水作

帽子店の看板圖案二種

DESIGNS FOR PRACTICAL SIGNBOARDS

実用看板意匠集

作司玉城岩　　　　　　　　　　　　　　種二匠意板看吊の内店

廣瀬貫川作

支那料理と鳥料理の屋上看板意匠

作雄達陽伊

種二案圖板看の屋水香と院髪美

作浩山須

種二案圖板看上屋の屋子菓と屋具玩

花屋と呉服店の屋上看板意匠二種　　　　　　　　　　池田木一作

8

電気応用広告集

Advertisements with Electricity
Denki ōyō kōkokushū

PUBLISHED MARCH 1930
17ᵀᴴ RELEASE IN THE SERIES

In the early twentieth century, electricity was the new medium of advertising design. It illuminated New York's Great White Way (a stretch of Broadway nicknamed for its theaters' blazing marquees) and transformed cityscapes into twenty-four–hour avenues of publicity. Veritable sculptures in light, electric signs brightly proclaimed the triumph of innovation while dazzling the eyes of nighttime passersby. Emulating the showmanship of Thomas Edison, commercial artists used this dynamic technology to charge businesses and commodities with the energy and excitement of the modern age. Electricity signified both civilizational progress and the novel entertainment of mass consumerism.

This volume's simplest examples are conventional signs illuminated by flood-lights, while others incorporate electricity into their designs, glowing from within to produce luminous signboards. Many involve electrified letters written in lights, arranged to dance up and across buildings in all kinds of typographic forms (pages 162–63). Monumental advertising towers echoed Gustave Eiffel's famed Paris tour de force with vertical electric and neon letters powerfully connecting earth and sky (page 160, top left). Two further examples on the same page depict the iconic publicity towers for the well-known brands Lion toothpaste (bottom left) and Jintan medicinal candy (top right) which illuminated the Tokyo sky for decades. Particularly associated with urban nightlife, many of the sample electric signs in this volume advertise drinking establishments, such as Bar Bacchus and Bar Minion (page 170). As other examples illustrate, electricity also bathes store interiors with light to enhance the display of commodities on shelves and in glass vitrines (page 161).

Essays in this volume explain how to create electric advertisements, categorizing types of lamps and technical shades and detailing how to produce illuminated letters and shapes. One vivid example displays an oversize pen piercing a large illuminated yellow ring, emblazoned with the words "Fountain Pens Tanaka" (*mannenpitsu Tanaka*), as the pen writes out the company name in romanized cursive below (page 169).

As elsewhere in the series, the romanized initials CAA cleverly sneak into examples throughout this volume (pages 171 and 174). This gesture was undoubtedly to remind readers of the acronym for Hamada Masuji's newly established professional group, the Commercial Artists Association (Shōgyō Bijutsuka Kyōkai).

(其二) 電氣應用廣告の夜の美觀

夜の王者電氣廣告塔

(A) 日本の實例　(B) エツフエル塔に施されたイルミネーシヨンの廣告　(C) オドールの廣告

電飾による店内の華麗な装飾の効果

電氣應用看板の各態（其一）

（其二）ネオンランプによるしるしの

（其五）電氣應用看板の各態

本文解説參照

電氣應用看板の各態 (其四) ネオンライトによるもの (其一)

(二其) 態亭品作秀優會院展ンイサ氣電年九二九一

一九二九年電氣サシン展覽會優秀作品各態（其一）

渡邊芳太郎案

電氣應用看板造型各態

(A) BAR RED

(B) BILLIARD HALL ミカサ / ビリヤードホール / MIKASA

(C) ELGIN / HIROKABE / 白元碆時計店 / GINZA

案 武中田 (B)(A)
案 千葉正章 (C)

電氣應用看板型造意匠

(A) 城戸萬象案
(B) 原　直久案
(C) 田中　武案

電氣應用看板造型意匠各態

萬年筆
タナカ
Tanaka
タナカ

田中 武案

電氣應用看板型造意匠各態 (ネオンと硝子板利用)

(B) (A)

(C)

案 象萬戸城 (A)
案 久 直 原 (B)
案 武 中田 (C)

態各匠意型造板看用應氣電

意匠型造板看用磁気電（のもるにに明照射反鏡凹） 柏垣知雄案

172

THE COMPLETE COMMERCIAL ARTIST

VOLUME 8

現代商業美術全集

(A)

JOSEPHINE

(C)

BAR フフー

FuFu

(B)

キリン

原 直 久 案 (C)(A)
渡 邊 辰 之 助 案 　 (B)

電氣應用看板型造意匠各態

13

岩田善六郎案　　　　　　　　　電氣應用看板造型各態

(其七) 料資考參　　　電氣看板造型各態

(其六) 料資考參　　　電氣看板造型各態

(其三十) 料資考參　　　電氣看板造型各態

(其二十) 料資考參　　　電氣看板造型各態

店頭店内設備集

9

Store Interior Equipment
Tentō tennai setsubishū

PUBLISHED MAY 1929
10TH RELEASE IN THE SERIES

While shop layouts give this volume its theme, exteriors figure prominently as well. Richly colored facades lure us into real and imagined retail establishments, with storefront and interior conceived as two sides of a single experience. From hand-drawn designs for fashionable exteriors, the volume travels indoors, immersing viewers in thematically syncopated decorative environments, including Japanese dance halls, candy stores, and even a modernist Warsaw apothecary designed by German architect Adolf Rading (opposite page, top). Figurative and abstract wall paintings travel around this pharmacy, both enveloping the visitor and creating an aesthetically synchronized atmosphere for commodities.

Architectural trends from Germany also appear in an illustrated design for a facade with projecting balconies inspired by the Bauhaus school's Dessau studio building. Elegantly curved and spacious show windows on either side of the doorway greet fashionable women consumers, while vibrant signage displays the store names "40th Street Store" and "Western-Style Clothes" in *katakana* and *kanji* (page 178).

Signature commodity motifs often link goods to their displays. One example uses the abstracted body of the dandified modern boy as a display prop to sell ties and hats to elegantly dressed male consumers (page 179, bottom). A watch and clock store promotes its wares with a gigantic timepiece out front and another projecting off the building as a signboard (page 180, bottom). And a design for a cinema-themed café and restaurant incorporates a miniature montage of film scenes and European poster designs to maximize associations with international entertainment trends (page 184).

This volume also includes diagrammatic approaches for readers hoping to absorb its teachings. For example, in an illustration of a storefront exemplifying "light's symphonic aesthetics" (*hikari no kōkyōteki bi*) after dark, labels point to the many kinds of illuminated elements that serve as beacons to passersby (page 181). Interior design ideas also appear in both axonometric sketches and floor plans with detailed layouts to help retailers plan their shop spaces. Every element contributes to the publicity function of the total design.

A

B

最も新しき意匠を示したる店内装備の例

(A) 薬化粧品店の壁面意匠と店内照明器具の考案 モーレンシ薬局 アドルフ・ラーデンダング設計
(B) 機械的構圖を最も巧みに藝術化せるレンズ店の壁面意匠及び天井照明器具の考案 ベルリン「フロム」レンズ店 アルツール・コルニック及びアヴィツマシ設計

古川末雄案 　　　　　　　　　　　　　　　洋品店の店頭意匠

角地に建つ青物店の店頭意匠及び計画書　　　　　　　　　　　　　　　竹村新太郎案

洋品店に用ひらるゝ陳列器具

(A) 野口　巌　案
(B) 渡　苅　雄　案

光の交響美的を示せる店舗の意匠　　　　　　　　　　　　　　　　　　　濱田増治案

A・反射間接照明の美　B・投光器によに間接照明　C・(裏面及び外文字の面裏照明切抜) D・鉄裏の装置さるれ隙間接照明　E・点滅移動の電燈看板(スラガ内部の爾に電燈あるもの) F・露出電球（各色種）G・露出電球(スラガ内部のゆるみに電燈あるもの) H・ネオンガス電気看板付) I・スラガ内部より照明　J・陳列窓内の光　K・テスドアンドグラスを透してし来る光の美

店頭店内設備集

間口四間の店舗前面意匠（何れにても向くもの） 濱田増治案

煙草店を兼ねた小さな藥局

濱田増治案

MITSUWAYAKUBO / DRUGSTORE

濱田増治案

カフェー及びレストランの壁に對する提案圖（二十一頁對照）

濱田増治案

A・新開ニユースの寫眞貼付場所　B・ガスランターの場所（注意・C
メニユーの　D・くしボしき別枠の掲示物の場所　E・談話用額面
のメニユー　F・
掲示及窓　G・料理本見本窓　H・キキネ貼付場所スーケ列置台
（給仕用）
L・ナキシフインナ等のケース入れ引出し　M・客用テーブル
N・客用椅子
（二十頁對照）

濱田増治案　24　光と色彩の効果を考慮したる商店の外観

売出し街頭装飾集

10

Street Sales Decorations
Uridashi gaitō sōshokushū

PUBLISHED DECEMBER 1928
6ᵀᴴ RELEASE IN THE SERIES

One of the most dynamic contributions to the series, this volume demonstrates the variety of outdoor publicity forms used to draw consumers into retail sales events. Heraldic arches and gateways with lights, decorations, and national flags became a standard part of urban pageantry in modern Japan from the founding of the nation-state in 1868. Traditionally, they had been used to decorate imperial progresses and spaces around the country, demarcate domestic expositions, inaugurate new railroad stations, and celebrate a host of other civic events (pages 204–5). In this volume, they also make shopping a festive occasion.

Many of the commercial examples depict temporary archways designed to project off the fronts of buildings, reaching out and enveloping pedestrians on the sidewalk (page 196, bottom). Some stand independent of buildings as oversize wayfinders, assuming the shapes of beckoning clowns, pointing arrows, and architectural beacons with vertically projecting flags and visual fanfare (pages 192, top, and 193). One music-themed example—a keyboard—goes on parade, carried by men in matching attire (page 189). Another design features a signboard with a gigantic ball held by an Atlas-like figure, reflecting the immense popularity of college sports, particularly baseball, with major contemporary rivalries emerging among Japanese universities (page 196, top left). For a sale directed at children, an archway is transformed into two gigantic cats with a fish-shaped signboard reading "special sale" whimsically mounted across their noses (page 199). There are even publicity arches for products as mundane as workers' shoes, promising respite for tired and aching feet (page 197).

Almost every facet of these commercial set pieces contains sales information, which runs in all directions: "end-of-year sale," "large sale," and "month and day [of sale]" (page 188), as well as "special sale" and "winter sale" (pages 200, top, and 201). Appeals to customers often subdivide the facade of shop entrances, transforming them into promotional palettes with messages such as "50 sen discount" and "Now is the time to shop!" cascading from the marquee to the street (page 202, top right).

The Ars compendium likewise doesn't waste an opportunity for self-promotion. One example with a large dark blue arrow shooting through a lilac-and-tangerine pillar topped with flags shows the way to a "store where you can subscribe to the Commercial Art Compendium" (page 202, bottom left).

編輯委員

濱田　増治
武藤　舟治
渡邊　菊一
田附　寅郎
仲田　定之助
宮下　孝雄
杉浦　非水
（イロハ順）

中里研三作

店舗前面装飾

岡村蚊象作

聯合売出し街頭装飾（人道入口に段とるいゝ装飾門）

田中良作

ピアノの広告のための案

広告假装行列意匠

店前賣出し街頭裝飾　（裝飾門式に工夫をこらせるもの）　石本喜久治作

齋藤佳三 作 　　　　　　　　　　　　　　電燈によりて効果を示す店前装飾

濱田増治 作 　　　　　　　　　　　売出し用装飾塔三種（店舗の前に建てるもの）

呉服店向き賣り出し看板裝飾　（和風趣味各種向き意匠）

藤澤龍雄　作

STREET SALES DECORATIONS

売出し街頭装飾集

運動具店向き買出し用上屋し製飾　前島誠一作

海産食料品店の買出し上し板製飾　小川金重作

カフェーの開業装飾　小松巻作

洋服店向き買出し街頭し装飾　仁井太郎作

靴廉賣の街頭裝飾（店舗より三角取りけつらべき大營の向きの店に對するもの近似）　新井泉作

北川隆三 作

(特に取替用吊り看板を店飾りょ直角に備へたる形式)

毛織物店向き賣出し街頭装飾

スペッシャル・セール

コドモヤ

作 雄秀岸

（匠意物装るに：天形稽業） 菓果前店のき向店品用供子

A　家具店向き屋上賣出し装飾
B　歩道の上に脇が聯合賣出しの装飾門
（屋上より三角形式につき出さるゝもの）

A　田口麟三郎作
B　梅田　穣作

造型的趣味ある売出し街頭装飾　（洋家具運動店其他インテカある味店に向くもの）　小川光三　作

(8) 同じく東京櫻田門外に建てられたるもの。
(9) 大正二年天長節の際宮城前に建てられたもの。
(10) 大正四年先帝御即位の際東京下谷に建てられたもの。
(11) 今上御成年式の際日比谷にたてられたるもの。
(12) 大正十五年立太子の際、宮城前に建てられたるもの。
(13) 大正四年　先帝御即位式の際、宮城前にたてられたるもの。
(14) 今上御成婚式の際、宮城前にたてられたるもの。

日本奉祝綠門の變遷

概觀

(1) アーチの基本形式。
(2) 憲法發布當時東京京橋通りに建てられたもの。
(3) 右と同橫、同所。
(4) 右と同樣、東京新橋附近にたてられたるもの。
(5) 日清戰爭當時京城にたてられたるもの。
(6) 日清戰爭當時東京日比谷にたてられたるものゝ一部。
(7) 日露戰爭當時に建てられたるもの。

出品陳列装飾集

11

Exhibition Display Decorations

Shuppin chinretsu sōshokushū

PUBLISHED DECEMBER 1929
15TH RELEASE IN THE SERIES

After the Great Exhibition's Crystal Palace debuted in London in 1851, world expositions became a global phenomenon. Commerce fueled these fairgrounds, infusing ornamented pavilions and stalls with creative energy. In turn, fairground designs profoundly influenced commercial enterprises in cities around the world.

Japanese cities were no exception. As a new nation-state attempting to define itself within the world theater, Japan focused particularly on exploiting this international arena for its cultural and industrial promotion. From exposition designs emerge new kinds of decorative sales kiosks—small-scale, stand-alone structures that serve as both trade booths and architectural signboards. Their designs are often fantastic and whimsical (opposite page, top right). Some are even engineered in eye-catching shapes with distinctive details, such as the roof projections that reference a jester-style hat on top of a Kirin beer kiosk (page 208, top left).

Alongside illustrations and photographs of European exhibition displays, this sourcebook shows Japanese examples promoting everything from Calpis soft drinks to Maruzen ink (page 208, top right and bottom right). Such designs include both outdoor constructions and indoor illuminated sales floors festooned with enticing commodities, as well as sales booths inside commercial establishments (page 209, top). Detailed floor plans and diagrams printed in a limited palette show a variety of shapes, including 360-degree stands that allow visitors to approach from all sides (pages 210–13). One projection even channels the minimalist structure of a Japanese teahouse, with service stations outfitted with small windows radiating from a central point in all four directions—a creative example of modernism meeting the vernacular (page 213, bottom right).

博覧會々場内特設小館外觀
(A) 一九二四年英國ウェムブレイ博に於けるお菓子店　(B) 同上煙草の小特設館

博覧會々場特設館及び陳列函外觀
(A) 一九二四年英國ウェムブレイ博に於ける工藝特設館　(B) 同上廣告塔式工藝品陳列函

EXHIBITION DISPLAY DECORATIONS

VOLUME 11

出品陳列裝飾集

(A・カルピス食堂 B・キリンビール食堂)
(C・丸善株式會社 D・佐久間建材工業所)

(日本最近博覽會に現はれたる小特設館類例 一九二八年日本平和紀念博)

日本の館内陳列様式類例

A・於ける商工獎勵館に於けるエスキモー商工會員の
B・陳列→一九二八年大禮記念博覽會に於ける宮田製作所の陳列
C・和博の木村に於ける陳列・D・平和博に於ける合資會社電線陳列

商品を象れる廣告塔及び設備的仕事を奉ずあり設備的特設廣告館類例

A・京都大禮記念博覽會に於ける山一證券株式會社
B・廣告塔・奉ずる仕事的設備あらライオン齒磨の設備

PLAN

小憩的阿屋設計

EXHIBITION DISPLAY DECORATIONS

出品陳列装飾集

計設店賣小外屋 63

計設店賣小外屋 62

計設店賣小外屋 65

計設店賣小外屋 64

屋外小賣店設計

屋外小賣店設計

体塾所と公衆電話室を兼ねたる小特設備設計

包紙・容器意匠図案集

12

Wrapping Paper and Container Design
Tsutsumigami yōki ishō zuanshū

**PUBLISHED APRIL 1929
9TH RELEASE IN THE SERIES**

This volume revels in the varieties of modern wraps, packages, and product labels, as well as their traditional precursors (opposite page). Examples include modern and colorful three-dimensional cosmetics packages for cheek rouge (page 218), as well as labels for canned and bottled food items like strawberry jam and small fish (page 219, top). On one page, ink bottle labels tout made-up businesses with placeholder names like "Iroha ink," referencing *iroha*, the traditional start of the Japanese alphabet, much as Western promotions might employ ABC (page 226). Opposite, "Kansai" (west) and "Azuma" (east) appear as directional placeholder names on labels for beer and fortified port wine (page 227).

To convey historical authenticity, labels for traditional products like sake (page 229) use expressive brush calligraphy.

Known as "the silent salesman" in Japan, decorated wrapping paper has long served as an important medium of commercial design. Some of its power came from customers using it repeatedly over time in an early form of recycling. In this volume, examples of floral and abstract decorative patterns appear in the style of resist-dyed *shibori* and *sashiko* embroidery (page 228, bottom right). There is wrapping paper for the well-known bookstore Shishindo (page 222, bottom left), as well as for stationers such as Bunpōdō, Kinokuniya, and Itoya, all still in business today (page 231, bottom right and top left, and 232, top, lower left). Another paper with figurative designs show servers holding a cornucopia of savory seafood snacks like *konbu* (seaweed), piles of dried squid, and *shishamo* (saltwater smelts) tied together (page 222, bottom right).

A particularly interesting brown, black, and white wrapping paper for the Naritaya theater's gift shop is shown wrapped around a conical container, the paper folded to look like a Kabuki actor (page 220, top). Its pleated paper garment appears to bear the three nested square boxes that repeat in the pattern behind it. Called *mimasu*, this pattern is instantly recognizable as the family crest of the famous Ichikawa dynasty of actors. The tiny actor even brandishes a small samurai sword.

日本固有の容器及び包装各態

日本に於けるけ函の外装意匠實例二種 （特に藝術的なものゝ）　　參　考　資　料

各種の函外装意匠三種（メアリカ）（A・石鹼 B・ゴム C・マッチ）　参考資料

池上重雄作　　　化粧品函の外装意匠二種

食料品罐詰用レツテル図案三種　　　　　　　　　　　　小津谷五碧作

詩的気分によるお化粧品店の包装紙図案（リスス愛行）　　　　夢考資料

作 雄龍澤藤　　　　　　　　　　（案考の器容と紙包）　劇場みやげ品の包裝圖案

菓子入函の外装形式と其図案

市川越夫 作

各種チユーブ容器の外装意匠四種 (A・糊B・はみがき C・繪具 D・薬品)

金子寛 作

地方土産品羊羹の包装意匠　　　　　　　　　　　　　　　　　　伊關達雄作

作 雄 瀧 澤 藤

箱四楽園ヶク〻張場用演洋び及料飲涼清

市川越夫作

關本有漏路作　　　　　　　　　　（壜の形とツレテル）インク及び藥品の包装意匠六種

洋酒壜張用レツテルの形式意匠と其圖案四種　　　　關本有漏路作

各種帯封用クリンヤルとも胴裏五種 47 各種クリンャレゲンラテンのルの各種形式童匠九種 (品部及び巻木等角トの) 46
朝影禮三作 朝影禮三作

藝術的包裝圖案資料 51 藝術的包裝圖案資料 タイヤ サヒベンのレーベル 「スケテマキク」製作の餞別用 50

作 寛子金

日本発泡酒用フタ圀三製作

包紙・容器意匠図案集

箱四例實式形をけ於に新句の店書び及店具房文

各種業態に贈答を示せ商店包装紙の形式實例四種
(A)反復模様・和風絶味によるもの・B)新折込模様によるもの
(C)反復模様・和洋風味によるもの・D)和風絶味によるもの

参考資料

各商店に於ける案內圖の袋と形式三種

参考資料

A

B

参考資料　　　　　　　　　　石鹸の包装紙意匠實例二種

石鹸堂生資

新聞雑誌広告作例集

13

Examples of Newspaper and Magazine Advertisements

Shinbun zasshi kōkoku sakureishū

PUBLISHED AUGUST 1929
12ᵀᴴ RELEASE IN THE SERIES

Newspapers were the dominant medium for commercial advertising in Japan, and their typically crowded black-and-white pages inspired vast creativity among commercial artists.

Many examples in this volume engage in visual and lexical play with letterforms. In an ad for Calpis, a cultured milk beverage containing probiotic lactobacilli, a series of illustrated figures contorts diagonally across a checkerboard to spell out the brand name "Ka-ru-pi-su" (page 236, top left). Another on the same page promotes Smoca, a brand of smoker's toothpaste, with the repeated tagline "ha ga ha ni naru Smoca" (literally, "the tooth becomes the tooth Smoca"). Here the first *kanji* for *ha* 歯 (tooth) is printed in black, while the second appears white with an outline, visually implying that if you use Smoca, the black tooth becomes the white tooth (page 236, top, lower left).

Newspapers often sold advertisements by the line, so advertisers sought to maximize promotional space while catching the reader's eye with bold motifs or an exclamation point (opposite page, bottom). Small figures can form larger *kanji* characters, as in a Meiji chocolates ad (page 242, bottom, upper left) with stick-figure children assembled into the character *haru* 春 (spring). An ad next to it for the same company masses together small *kanji* characters for *hana* 花 (flower) to form blooming trees.

Recognizable trademarks and logotypes are essential in this competitive visual space. Among them, we find Kaō Soap's logo of a crescent moon face hovering over a tennis player (page 239, center left), as well as a sketch of a modern couple—the consumers of Morinaga's popular milk chocolate—posed in a triangular design next to the company's name (page 238, bottom right). The visual grammar of the newspaper also encourages experimentation with abstract figures, as seen in a series of Hermes-brand whiskey ads that use simple geometric forms to suggest affable characters: the modern boy and girl enjoying cocktails, waiters carrying drinks to thirsty patrons, and tipsy revelers enjoying their libations (page 237). The volume prominently features familiar brands that invested heavily in advertising, including Akadama port wine, Kirin beer, Ajinomoto seasoning, and Kikkoman soy sauce (page 241). And a lively assortment of *kinema moji* (cinema letters) represents the distinctive expressive and ornate styles of letterform design for film publicity (page 243).

(一）文字主体とせる広告範例（特に標題を主とせるもの）

(二）文字を主体とせる広告範例（文字の印象を最も明瞭に表現し得るもの）

(七) 文字主体とせる廣告範例 (文配列の美術的表現と繪圖)

(八) 文字主体とせる廣告範例 (文字の配列及其の表現法)

43

（のちれ性品るお味野でり上に間的ゐ謎のトツカ　（丸）例能告廣るせ し体主な張稲で及トツカ

キリンビール

一打入 牛打入 化粧函

冬季には特に
キリン黒ビールを
お勧め致ます

歳末年始贈答品

麒麟麥酒株式會社

年末御贈答には
コレが一番です！

キッコーマン

野田醤油株式会社

味の素

AJINOMOTO

卓上瓶

こいつァ旨いぞ
よしッ
今日から飲むぞ
うんと肥へるぞ
目方も殖へるぞ
そして一番
馬力を出すぞ！

赤玉ポートワイン

（カットの描現長ている於法も最力強くせるもの）　（八）カット及び繪畫を主体とせる廣告範例

（カット及び繪畫を主體とせる廣告範例）（二十）　カット及び全體の構圖に漫畫的興味をもつて表現されたるもの

（カット及び繪畫を主體とせる廣告範例）（三十）　時宗の崇拜と戀慕を抱くて情的に表現されたるもの

各種業態によるに個性的形式の広告範例（二）　（マキネに脚本るす廣告各形式）

写真及漫画応用広告集

14.

Advertisements with Photography and Cartoons

Shashin oyobi manga ōyō kōkokushū

PUBLISHED AUGUST 1928
3ʳᵈ RELEASE IN THE SERIES

Grouping together the seemingly disparate topics of photography and cartoons in advertising design, this volume surveys a broad aesthetic range, from photomontage to fanciful hand-drawn caricatures. Although strong contrasts between apparent mechanical verisimilitude and individual expressiveness divide these two mediums, examples like Bauhaus proponent Nakada Sadanosuke's volume-opening creative advertising photograph play with bridging the gap (opposite page).

The first half of the volume features photographic work, including experiments of the Soviet and Bauhaus avant-garde (page 249), which likely served as inspiration for original work. One sample design advertises *In Black and White*, a psychological murder mystery by renowned novelist Tanizaki Junichirō, by solarizing and dividing a photograph of a Japanese woman's face into quarters in a play on the book's title (page 246). Another lively photocollage cuts together outstretched high divers and other athletes in a celebration of sports (page 248).

The mood shifts in the volume's second half toward the comical and satirical spirit of cartoons. In one example, a flyer for life insurance represents the policy anthropomorphically as the "life insurance man." With a rolled contract for his head and a robe covered with the character for "life," this sword-bearing protector confidently extends a hand to the white-collar salaryman, promising to guard his young wife and infant (page 251). In a more modern pictorial idiom, one page shows caricatures on flyers advertising Ginza candy, Red Cow condensed milk, fish miso, and something referred to as "contemporary beans," the latter of which energetically pops out of a canister that's propped on the feet of a person reclining with his legs in the air (page 252). An illustrated flyer translates the spirited fun of traditional Japanese toys, cheerfully scattered around the page (page 258). And a later spread features a charming collection of illustrated match labels, positioned across from humorous cigarette cases that blur the line between childhood play and adult trinkets (pages 260–61).

仲田定之助作　（同氏解説参照）　　　　　　　創作廣告寫眞「夜」

作政田森　　　　　　　　「黒と白」眞寫告廣作創

森田政雄作

創作廣告寫眞「アルプス」

仲田定之助作　　　　　　　　　創作廣告寫眞「スボーツ」

（雜誌バウハウスの表紙）廣告寫眞實例

廣告寫眞實例（二及ニ三に插圖例）

23 22

廣告寫眞撮影安料
(A) 反射光線によるもの　カシ・エストレエフの作
(B) 反射光線によるもの　エフ・アネルの作
(C) ハーコーブウオタイトルの窓　モホリナギーの作
(D) オフホネオチグーブ　モホリナギーの作

廣告寫眞撮影資料（フオトモンタージユに依る）
(A) 新案の廣告寫眞　(B) 新案の廣告寫眞

29 28

作 天川下
四
THE COMPLETE COMMERCIAL ARTIST
VOLUME 14
現代商業美術全集

池部 鈞作

食料品のチラシ廣告四種

作 天 樂 澤 北　　　　　　　　　　　　　　　　　　　　　　　　　　　　　一タスボの藥膏

ひろく
めづらしいものが
たくさん
まいりました

静かで明るくて
お近くにカフヱーが出来ました

前川千帆 作

飲食店のチラシ廣告二種

"Quick, Mama! The Flit!" —Advt.

"Don't worry, Papa, Willie just swallowed a bug, and I'm having him gargle with Flit." —Advt.

廣告用漫畫カット各種　（A・櫛とブラシ　B・喫茶店　C・自動車　D・海水着　E・歯に關するもの）　宍戸左行作

作 郎四上川　　　　　　種各料資物動トツカ畫漫用告廣

原 万 助 作

漫画式マッチレッテル六種

実用図案文字集

15

Applied Lettering Design
Jitsuyō zuan mojishū

PUBLISHED APRIL 1930
18ᵀᴴ RELEASE IN THE SERIES

Responding to the commercial art profession's interest in the art of letterforms, the expressive designs of this volume leap across the pages in all directions. The editors address lettering both historically—with photographs of examples reaching back to the earliest written forms (opposite page)—and in conversation with the latest Western trends (page 264, top and bottom right). Essays in the volume extend this approach with discussions of the experimental letterforms of Bauhaus designers, the progressive standardization of *kanji* characters, and the prehistory and nineteenth-century development of Gothic lettering in Japan.

At several points across its pages, this volume explores the elementary, modular forms of letters in detailed charts of *kanji* characters; the two phonetic syllabaries, *hiragana* and *katakana*; and romanized letters (pages 266, 269, and 286). Elsewhere, arrays of popular advertising terms demonstrate new styles that play with stroke weight and texture, ornamentation, color, and even volumetric rendering (page 267, top). These include "new publication" (*shinkan* 新刊) at the start of the second row on the recto page, and "price tag" (*shōfuda* 正札), "lottery" (*fukubiki* 福引) and "free gift" (*keihin* 景品) in descending order down the far left column of the recto. In one full-page composition, a round sign exclaiming "new store opening" (*kaiten* 開店) caps a sign for stationery goods and pens (page 273). Another promoting Tonca Toys (no relation to the Tonka company) imbues Japanese and roman characters with a linear style shared by the ad's graphical illustrations (page 282).

Other ads go a step further, transforming lettering into illustration: Four clever designs for Kotobukiya's Akadama (Red Ball) port wine, a popular fortified sweet beverage, depict the character *aka* 赤 (red) as a human figure carrying the character *dama* 玉 (ball) or using it as a piece of furniture for sitting on and for serving (page 285, bottom left). The pictorial use of characters is further drawn out on a page where, in the first column of characters, three stacked *kanji* for camera (*shashinki* 写真機) each assume the form of a bellows camera, while fiery characters promote fire insurance (*kasai hoken* 火災保険) below. In the second column, a frost-laden character conveys the cold of winter (*fuyu* 冬), and teeth grin from the characters for toothpaste (*hamigaki* 歯磨) at the bottom of the last (page 287).

While most letterform design here is modern in style, the volume also presents Japanese calligraphic scripts associated with Kabuki theater and traditional products such as sake (page 264, bottom left).

文字の史的研究資料（其一）
（矢島週一氏の史的變遷記事參照）
(A) 埃及の繪畫文字　(B) 古代埃及の楔形文字と石版文字の對照　(C) 楔形文字　(D) 楔形文字の分解

稲葉一馳案

各作家創作圖案文字範例

商店會社

特別原價販売

割引大売出

中元歳末

小谷喜一案

各作家創作圖案文字範例

APPLIED LETTERING DESIGN

各作家創作圖案文字範例　　小谷喜一案

実用図案文字集

高級品

急行�廃止
蔵ばらし
端午・出展・福

中元・桃の節句・松柄・流行

千葉正章案

各作家創作圖案文字範例

陣列。

尚美

春から夏へかけての御召物
とてふさはーい訪向着、丸物
帯、片側帯御召
小紋、友禅半襟、
男物着尺地など。

川原正義案

春夏秋冬 信憑 大割引 新柄新製品案内

ABCDE

小林忠孝案

各作家創作圖案文字範例

特價品 文房具 繪筆 小間物 開店

五月反形陳列 雅人形陳列會 年末年始御贈答案内

小林忠孝案

各作家創作圖案文字範例

洋品雑貨呉服

景品福引

小林忠孝案

各作家創作図案文字範例

いろはにほへとちりぬ

特別奉仕

廉賣

聯合賣出

小林忠孝案

各作家創作圖案文字範例

聯合

断然

照

爽8

はるの

帽子

快

角帶

和別賣出

日本正

商業美術家協會研究所

各作家創作圖案文字範例

第1回展 テラ工藝品
TERRA

鹿島光夫 案

各作家創作圖案文字範例

からたちの歌

赤い窗 夜

私の太陽

ポスター展覧会

音楽 クーポン

新しい言葉

岩田善六郎案

各作家創作圖案文字範例

新 若衆 現代的
創作 流行 方
商業美術家協會研究所 各作家創作圖案文範例

金銀鐘
時計鎖
製圖器械
鯛占

村瀬美樹案

各作家創作圖案文字範例

棘の楽園

惡

漫画謝肉祭

明治奇聞 とかげ娘

夢

恐怖の歯型

TORIO

小谷次郎案

各作家創作圖案文字範例

傾向果玩具研究所 TONCA·TOYS

鹿島光夫 案

各作家創作圖案文字範例

築地三新山小

1234567890

例範字文案圖作創案作名

圖案文字作法　（文字慳化法の作例）

矢島週一案

各作家創作圖案文字範例（畫的興味文字）

実用カット図案集

16

Applied Illustration Design
Jitsuyō katto zuanshū

PUBLISHED JUNE 1929
11TH RELEASE IN THE SERIES

Small, simple, often monochromatic graphic illustrations were common additions to Japanese advertising and publishing designs. This volume collects all manner of practical motifs, including many that readers could incorporate directly into their publicity as what we would now call clip art. Fit for any purpose, illustrations could be scaled as necessary and integrated into everything from matchbox labels to flyers to posters. Used as decorative border elements or corner ornamentation, they could convey important psychological messages to consumers.

Many examples capitalize upon the attractions of modern affluence and conviviality with figures engaged in popular leisure activities (opposite page). On one spread, a young woman in front of a mirror applies makeup and has her hair done for an evening out, while around her cosmopolitan denizens of cafés and dance halls revel and drink the night away (pages 290–91). The modern girl with her rouged face, short-cropped hair, and sassy fashion style appears repeatedly throughout the designs, as on one page featuring a variety of poses (page 292). Her more traditional kimono-clad sister with elaborate wig coiffure and decorative parasol shows up a few pages later, drawn in a similar style and printed in the same palette (page 295).

Elsewhere in the volume, everyday fashion items appear laid out as small individual motifs: Handbags, collars, *obi* (sashes), *tabi* socks, *geta* sandals, and Western-style shoes sit across from women's Western-style accessories like parasols, shoe-socks, shawls, gloves, and decorative hair combs (pages 296–97). Motifs for modern writing supplies like a pen-and-ink set (made by a fictive company with the placeholder name RRR), a notebook, and letter paper from the well-known stationery store Bunpōdō fill another layout (page 298).

As is often the case in *The Complete Commercial Artist*, animals prove just as popular as their human counterparts. In this volume, whimsical storybook creatures swirl around central octopus and crane illustrations on facing pages (pages 300–1).

商用カット圖案範例 (ウラジミル・ボリスキー作)

漫畫式商用カット圖案資料　(アメリカ)

漫畫式商用カット圖案資料　(メリカ)

作 雄 龍 澤 藤　　　　　　　　　　　料資榮圖トツカ用商るすと題主を人婦風洋

藤澤龍雄 作　　　　　　　　　　　和風婦人を主題とするカット商用図案資料

伊關達雄作

各種商品を主題とするカツトの圖案資料

婦人用品を主題とすると豆カツト図案資料

伊関達雄作

作 泉 井 新

特殊な表現によるカット商用図案資料

川上四郎　作

動物を主題とするカット用商圖案資料

作郎四上川　　　　　　　　料資案圖トッカ用商るすと題主を物動

文字の配列と文案集

17

Lettering Layout and Copywriting
Moji no hairetsu to bunanshū

PUBLISHED FEBRUARY 1930
16TH RELEASE IN THE SERIES

This volume walks through a variety of approaches to the editorial layout of the printed page, offering a palette of mockup thumbnail designs with text placed in different positions and compositions—off-center, staggered, stepped, and diagonal—to animate the page for the reader (pages 304–6). It also includes advice on proofreading and a handlist of popular advertising catchphrases—such as "low cost and high efficiency" and "picture of health"—in both English and Japanese. Many advertising designers were also creative copywriters.

Multidirectionality is inherent in the Japanese written language and enhances the possibilities of communication through editorial design. In this volume, *kanji* characters or *kana* syllables, whether hand-rendered by brush in a calligraphic style or machine-printed, are often fashioned into dynamic shapes, such as the spiral of text used in a promotion for the reconstructed metropolis of Great Tokyo after the Kantō Earthquake of 1923 (opposite page, top right). One of the volume's essays explains the distinct conventions of Western writing traditions—showing, for example, how Western mail is postmarked horizontally in contrast to vertical Japanese postmarks.

Many examples display aestheticized texts in Euro-American advertisements for popular brand names like Campari liqueur, Guerlain and Coty perfumes, and Dunlop tires (page 308). Other examples show how varying the hierarchy, overall shape, and composition of text affects the page's visual impact (page 307). Hand-lettered slogans from Western show windows proclaim news of sales and services (page 309, bottom). On the same spread, a grid of promotions for Japanese companies employs visual puns: At the bottom of the first column, an advertisement for *tabi* socks sits in the outline of the sock's divided-toe footprint; Mizono tea promotes itself with ad copy shaped into an exclamation point at the top of the second; and an ad for Smoca-brand toothpaste inserts pithy statements into the compartments created by a large *ha* 歯, the character for tooth, at the top of the third (page 309, top).

日本及び支那の敎化宣傳標語印刷物

(A) (B) (C) (D) 東京市自治宣傳　　(E) 支那孫文ロスゲーシ刷込のみ書簡箋

(二）例範礎基列配字文告廣

廣告文字配列基礎範例（一）

(三)廣告文字配列基礎範例
(四)廣告文字配列基礎範例
(五)廣告文字配列基礎範例
(六)廣告文字配列基礎範例

イタリー雑誌廣告文字配列範例

米獨佛廣告文字配列範例

チラシ・レッテル図案集

18
Flyer and Label Design
Chirashi retteru zuanshū

**PUBLISHED NOVEMBER 1928
5TH RELEASE IN THE SERIES**

Single-sheet flyers or leaflets—*chirashi* in Japanese—were a popular and inexpensive form of commercial advertising. This volume introduces the basic features of the advertising flyer, as well as the equally popular promotional form of the stand-alone affixable label, explaining how to design them for maximum impact.

Its focus includes the important category of the designed matchbox label, often associated with trendy destinations like modern cafés and upscale hotels. The high collectibility of matchbox labels in Japan facilitated widespread popular interest in modern graphic arts (pages 314–15). A significant Japanese export product, the matchboxes also address international audiences (opposite page). Among the other formats on display are advertising cards for cafés, dessert parlors, and hotels (page 321).

On one page, luggage labels produced as travel souvenirs feature tourist destinations such as the Japanese Alps and the islands of Matsushima, as well as traditional inns or *ryōkan* (page 319). On the facing page, flyers for children's goods employ the lively themes of a springing jack-in-the-box and a kangaroo with its pouch filled with toys (page 318). Leaflets announcing a new magazine and a store feature sporty young cosmopolitan figures in active poses (page 320). Two design examples advertising winter and spring clothing sales create bold graphic compositions using natural motifs (page 316, top), while on the facing page flyers for "Ars Western-style Clothing" showcase illustrations of fashionable gentlemen posing and promenading through a promotional gateway (page 316, bottom). Japanese-themed flyers promoting furniture shops and futon stores include an image of a kimono-clad woman putting her bedding out on the line in the sunshine (page 317, bottom left). Toward the back of the volume, before the usual sections of essays, black-and-white reproductions of flyers from popular retailers including Mitsukoshi and Maruzen demonstrate a variety of modern styles used to advertise spring hats and fashions (page 322).

東洋風の輸出向日本製マッチレッテル趣味資料

西洋家具

西洋家具店のチラシ

信田不洋作

313

FLYER AND LABEL DESIGN

VOLUME 18

チラシ・レッテル図案集

伊關達雄作　(A・旅館　B・ビヤホール　C・洋食屋　D・毛糸屋　E・洋品店)　ポスタースタンプ五種

BA 須岸 作浩山
DC 秀雄 作秀岸
JIHGFE 秋吉秀雄 作

作四間風

案内状表紙圖案二種

河合間作

シラチのやかとんふ

シラチの蚊帳及蒲團

子供向きのチラシ二種 (A・玩具店　B・菓子店)　　川上四郎作

案内用絵葉書二種 (A・新刊案内葉書 B・開店披露案内状)　小池巖 作

チラシ図案實例四種 (A・三越 原万助作 B・資生堂 澤令花作 C・丸善 大浦周藏作 D・三越 須山浩作)

チラシ図案実例二種

新案商標・モノグラム集

19

New Trademarks and Monograms

Shinan shōhyō monoguramu-shū

PUBLISHED SEPTEMBER 1929
13TH RELEASE IN THE SERIES

Japan instituted its first modern trademark law in 1884, securing the trademark's role as a commercial identifier. Although universal enforcement still did not exist when the compendium was issued, an essay in this volume discusses trademark copyright law and infringement, signaling its growing relevance to designers.

The volume's illustrations cover a vast range of designs, both old and new. Some traditional Japanese trademarks depict gods of fortune, such as Ebisu with his pronounced ears and pendulous earlobes symbolizing wisdom and good luck (page 326, top row, right). Family crests, known as *kamon* and referred to as monograms in the volume, were often associated with elite aristocratic and samurai families (page 327, top left); here they contrast with an adjacent page of coats of arms from foreign countries (page 327, top right).

Businesses also made use of Japanese crests, often imprinted on hanging doorway curtains (*noren*) and employee robes (*happi* coats). An array of traditional crests that became trademarks appears on a page dedicated to department stores like Daimaru, Mitsukoshi, Takashimaya, and Isetan, all with roots in the Edo period (page 328, bottom left). Opposite, a page shows modern trademarks for well-known companies such as the Mitsubishi mark at far left in the bottom row, its three-diamond symbol reflecting the meaning of its name (page 328, bottom right).

Each Japanese municipality established its own trademark, a selection of which are presented in this volume (page 327, bottom left). In the top row, Tokyo's design based on the Buddhist dharma wheel (right) appears next to marks for Kyoto (center) and Osaka (left). Elsewhere appear monograms for schools and religious institutions (page 328, top left and top right), as well as logos for medicinal products (page 329, top right) and toiletries (page 329, top left).

A wide array of trademarks for food also make an appearance (page 329, bottom left). Many feature calligraphic or stylized letters, including those for Yamasa soy sauce (top row, center), Hakutsuru sake (second row, center), and Kikkoman soy sauce (third row, right). More figurative designs include the Morinaga confectionery's flying angel with the founder's initials of TM (fourth row, left), the offensive straw-sipping blackface figure of Calpis lactobacillus beverage (fourth row, center), the chimerical flying giraffe (*kirin*) of Kirin beer (bottom row, right), and the housewife promoting Ajinomoto's revolutionary MSG flavor enhancer (bottom row, left).

日本織物商標レツツル

日本各種商標ヅツテル

各國國家の紋章 (A シロフ・B ゲルマ・C 北アメリカ・D メキシコ・E ペルシャ・F アラビア)

日本家紋類例

日本学校章標類例

(A) 東京大立学・(B) 京都大学・(C) 早稲田大学・(D) 京都帝国大学早稲田大学・(F) 明治大学拾大学・(G) 第一高等学校・(H) 京都中央美術学校・(I) 京都中央美品学校・(J) 東京美術学校・(K) 宮田絹糸紡績・(L) 一高等学校

各種宗教の所属標類例

(A) 日連宗・(B) 扶桑教・(C) 御嶽教・(D) 天主教・(E) 天理教・(F) 金光教・(H) 天台宗・(I) 大社教・(J) プロテスタント・(K) キリスト教・(M) 仏教・(D) 普観宗・(L) 宗教団

日本著名百貨呉服店類例

(A) 高島屋・(B) 越後屋・(C) 大丸屋・(D) 龍本店・(E) 大倉屋・(F) 恵比寿屋・(G) 大倉商店・(H) 合名会社・(I) 菱屋・(J) 作本店・(K) 伊勢屋・(L) 堀内店・(M) 丸屋・(N) 桐屋

日本各会社銀行類例

(A) 日本郵船・(B) 大阪商船・(C) 日本海軍・(D) 大日本製糖・(E) 日本窒素工業・(F) 東京電燈・(G) 大阪瓦斯・(H) 日本石油・(I) 大日本麦酒・(J) 三菱銀行・(K) 住友銀行・(L) 日本勧業銀行・(M) 東京銀行・(N) 三井銀行・(O) 三菱合資・(P) 三井物産・(Q) 岡崎銀行・(R) 安田銀行・(S) 六十九銀行・(T) 郡是製糸・(U) 日立製作所・(V) 富国生命・(W) 三菱重工業

日本印章類例

日本文標字類例(一)

日本文標字類例(二)

歐文モノグラム類例(七)

歐文モノグラム類例(八)

観念類似の例

ふ。登録査定を受くるためにも商標の意匠に注意するを可とするは営業上から観ても意匠を凝らすことを可とする。文字商標に於いても文字の態様に自ら其意味を現はせることは面白いことである。

これは商標案出又は考案に就いての最も大切なる要件であると思はれる。

次ぎに商標の選擇に就き最も注意すべき事項は、他人の登録商標に類似せざる即ち他人の専用権を侵害せざるものであることを要する。類似とは、

感じを與へ、其商標を使用した商品に惹きつけられるやうに仕向けねばならぬ。従つて黒白二色のみの商標よりも着色ある方が顯著になるのを通例とするが、其着色に注意し、意匠を重んじ、包装其他との調和を缺かないや—の如くその調製が容易であり、理解し易くうにしなければならぬ。又商標の一部をなす文字や意匠が優れてゐるといふことよりも、着色と意匠との完全なる調和といふことが一層重要な事柄である。ともかく商標はポスターなければ、はつきりした印象を與へることは出來ない。殊に着色が餘りデリケートに出來てゐると、ぼんやりした商標となつてしま

其有する特性が顯著でなければならぬ。又近くても遠くても何處から見ても見易いものでなければ、はつきりした印象を與へることは出來ない。

稱呼類似の例

小印刷物及型物図案集

20

Small Printed Matter and Pattern Design

Shōinsatsubutsu oyobi katamono zuanshū

PUBLISHED MAY 1930
19TH RELEASE IN THE SERIES

In this volume, every paper surface, no matter how diminutive, is a potential promotional space. From animal- and human-shaped paper cutouts and decorated menus (opposite page) to embellished coupons and tickets (pages 336–37), its examples show off the many ways one could apply advertising ingenuity at all scales.

One set of dynamic abstract illustrations features a perennial marketing favorite—modern girls with their signature marcel-wave hairstyles—along with a red-suited hotel bellboy carrying gift packages (page 348). On a grid of black backgrounds, brightly colored designs promoting leisure travel incorporate the steaming symbol for hot springs (*onsen*), while an abstracted train line shows a target pinpointing the destination for a short daytrip nearby (pages 340–41). Decorated papers to use in calling cards, stationery, and labels (pages 343, top left and bottom, and 352), and calendars with animal, human, and musical motifs (pages 342, bottom right, and 358–59) exemplify how design was increasingly permeating every aspect of daily life in modern Japan, especially leisure and entertainment. Highlighting the country's emergent interest in jazz, an event flyer featuring an animated trio of musicians with two-tone faces invites visitors to a musical jam session (page 354).

Amid such up-to-the-moment themes, traditional fabric patterns abound in menu and flyer ornamentation, including patterns in the style of resist-dyed *shibori* and embroidered *sashiko* that combine abstract geometric shapes, decorative dots, and floral motifs, such as the popular hemp leaf (*asanoha*) with its graphic six-pointed star grid (page 356, top right). Elsewhere, designs advertising a barber shop and a women's store compellingly balance stylized lettering and illustrations, even employing English-language text as a collage element to heighten the visual interest of a well-coiffed figure (page 351). The overall mood of the volume is bright and upbeat, offering myriad design interventions to publicize more vividly the pleasures of modern life.

髪ナクレス参考資料（二）

髪ナクレス参考資料（三）

作 碧五津谷小　　　　　　　　　（種三券場入）案圖作創物刷印小

作佛如淵岩

（種六ブムタス―タスポ）案圖作創物刷印小

小印刷物創作圖案（ポスターあスタンプ六種）　　岩淵如佛作

近戲の旅
二十四時間

恋の病は
有馬へ御座れ

西岡みはく作

清水芳郎作 （ポスタースタムプ七種） 小印刷物創作圖案

小印刷物創作圖案（變チラシ各七種）　田中武作

小印刷物創作圖案 (入場券表紙)

加賀田省三 作

小印刷物創作圖案 (宿泊券)

朝影禮三 作

龍田文二 作

龍田文二 作

龍田文二 作

作案　河村

作術芳本熊　　　　　　　　　　（ドーカヨシ）案圖作創物刷印小

1940 APRIL SUNDAY 27

熊本芳衛 作

キリン屋洋品店

1930
APR
20
-SUN-

ポンプ店
C A

1930
四月
27
日曜日
火の用心

MEMO

・27 APRIL・

作郎六善田岩

（カレンダーニ種）案圖作創物刷印小

渡邊辰之助作

カタログ・パンフレット表紙図案集

21

Catalog and Pamphlet Cover Design

Katarogu panfuretto hyōshi zuanshū

**PUBLISHED NOVEMBER 1929
14ᵀᴴ RELEASE IN THE SERIES**

This volume illustrates a wide range of possibilities for designing journals, books, catalogs, and pamphlets, from early modern Western leather bindings and the black-and-red papier-mâché case of a commemorative book by the Wiener Werkstätte collective in Vienna (opposite page, top and bottom) to contemporary Japanese designs by prominent modern commercial artists like Takehisa Yumeji (page 364, top right).

Covers of art and literary magazines figure prominently. Some selections, such as one for the journal *Young Grass* (*Wakakusa*), reflect the pastoral lyricism of their interiors' modern poetry and aesthetics (page 364, top right). Others, such as the cover of the coterie magazine *Creative Age* (*Sōsaku Jidai*), foreground abstract geometric compositions that gesture to the experience of the modern city (page 364, bottom right). These Japanese magazines exhibit a more pronounced hand-drawn sensibility than typeset European artistic publications such as *L'art vivant* and *Cahiers d'art* (page 365, bottom).

The volume explores the relationship between cover and content in designs for books as varied as detective novels, the complete works of famed author Natsume Sōseki, Japanese theatrical plays, a geography of Japan, works of social criticism, explorations of Japanese genre painting, and lectures on general cultural topics (pages 366–67). Colorful playbills issued by popular theaters and cinemas (including the Shibazono and Shōchiku cinemas) feature photographs of modern actresses and dancers—or sometimes just titillating images of their body parts, particularly their legs—as well as abstracted sketches of nude female figures (page 368). Designs for catalogs selling books and art supplies appear alongside clothing catalogs advertising the latest seasonal fashions (pages 370–71).

Not forgetting the inside of a book's cover, the volume also celebrates the vast creative possibilities for ex libris bookplate designs with a charming daruma doll, a Portuguese trader and ship, a Noh theater mask, Edo-style courtesans, and dancing nudes, a contemporary favorite (pages 372, bottom left, and 373).

ドイツ及スーリタス一古今の書籍装幀の資料

(A)(B)ドイツ十七世紀時代 (C)ドイツ現代 アルバート・フーブス作 (D)スーリタス―最新傾向スキンウ製所作作品

明治末期より大正初期に於ける名著と名家の表紙装釘

明治四十二年文泉堂發行　岡野榮装釘　泉鏡花作　(B)　小説「凡人」　高濱虛子著　明治四十二年春陽堂發行　石井柏亭装釘　(A)
明治四十四年北原白秋装釘　(D) 　小説「白鷺」　泉鏡花作　明治四十三年春陽堂發行　名取春仙装釘　(C)　小説「神鑿」　花
鏡花作　明治四十五年春陽堂發行　鈴木三重吉著　(E) 　小曲集「おもひで」　北原白秋著　四年東雲堂發行　橋本邦助装釘
大正元年左久良書房發行　(G)　「幾内見物大阪之卷」　幾尾文淵堂發行　大正四十五年金尾文淵堂發行　中澤弘光装釘　(F)　「三津さん」
「白鳥小品」　正宗白鳥島著　大正元年春陽堂發行　正宗得三郎装釘　(H) 　小説「髪」　山田花袋著　書房發行

3

明治後期に於ける名著と名家の書籍表紙装釘

(A) 武内桂舟装釘　明治二十九年春陽堂発行　小説「浮木丸」　尾崎紅葉著　明治二十九年春陽堂発行　(B) 武内桂舟装釘
(D) 結城　紀行「歐米山水」　大橋又太郎著　明治三十三年博文館発行　(C) 中村不折装釘　小説「網代木」　川上眉山著
素明装釘　与謝野寛編　詩集「カタツデ」　明治三十四年新詩社発行　(E) 鳥居清忠装釘　明治三十六年緑文堂発行　山岸荷葉
著　小説「五人娘」　(F) 鰭崎英朋装釘　明治四十年春陽堂発行　長谷川二葉亭訳　小説「其面影」　(G) 橋口五葉装釘
小説「うき草」　長谷川二葉亭訳　明治四十一年金尾文淵堂発行

日本雑誌表紙類例 (A・竹久夢二作 B・岸田劉生作 C・森田恒友作)

グラフス美術工藝雑誌表紙類例

豫約出版物內容見本表紙類例

（表紙類例）　日本キネマ グロリア 芝園館 C・D, 松竹座）

カタログ及び目録表紙意匠作例　（A・文房具店向き　B・書店向き）　商業美術研究所　稲垣知雄作　（濱田増治選）

（三越影劇(A)
　作郎六善田君(B)）
（渋谷増田漆
　所究研機美商）

（今肉店具身裂-B　今肉店具玩-A）
　例作匠意紙表グロタカ

日本エキスリブリス類例　（日本蔵票會作品集より）

日本趣味広告物集

22

Advertisements in Japanese Taste
Nihon shumi kōkokubutsushū

PUBLISHED JUNE 1930
20TH RELEASE IN THE SERIES

As demand for Western-style goods grew, the continued appeal of Japanese-style products, such as kimonos and traditional drinks, food items, and sweets, fueled distinct modern marketing that catered to what became known as *Nihon shumi*, or Japanese taste. The compendium editors' choice to dedicate a volume to the theme reflects the importance of this sector, characterized by aesthetic references to earlier Japanese forms of display design and packaging, mostly those associated with the bustling commercial culture of the Edo period (1603–1868).

Edo-period signboards (*kanban*), painted or creatively carved in the shapes of various products, prove especially vibrant sources of inspiration (pages 384–85 and 388–89). So do decorative leaflets (*bira*) (pages 394–95) and other printed publicity featuring beautiful kimono-clad women and dramatic Kabuki actors (opposite page and 396). Demons (*oni*), animals, and vegetables are also common themes.

The longstanding Japanese tradition of commercial woodblock printmaking, which often served as advertising for merchants, products, services, and entertainment (erotic and otherwise), leaves its mark throughout the volume. One page of Edo-era prints depicts stylish female customers at the textile and kimono merchant Mitsui Gofukuten (page 381). This predecessor of the Mitsukoshi department store was founded in 1673, demonstrating the centuries-long genealogy of creative advertising in Japan.

Senjafuda—votive slips, stickers, or placards traditionally posted on religious buildings, affixed to wood pillars and doorways—also make an appearance in the modern period, featuring Edo-style scripts that nostalgically harken back to a lively cultural past (pages 378–79). Similarly, *noren*, decorated shop curtains in vertical and horizontal formats (pages 390 and 392–93), along with *chōchin*, illuminated paper lanterns (page 397), and *nobori*, vertical banners (page 391), signify a dynamic commercial legacy.

Design in Japanese taste spotlights established calligraphic scripts and familiar natural, figurative, and geometric design motifs from prints, textiles, theater, and yearly festivals, as evidenced by a striking collection of cloth banners (pages 382–83). Yet even within this seemingly classicizing category, which looks to the past for inspiration, the variety and vibrancy of early modern Japanese advertising forms, including the range of scripts, is stunning.

種各物刷色札納

11

劇物にようる本日趣味廣告（ラビ繪）

刷物によるも日本趣味廣告（納　札）

天愚孔平先生相傳　千社膏
● 神仏一切堂宮に張りてよし
本家　東京浅草壽町　山本江銀

をり捌所　浅草一のじ乃　赤門金か乱堂
其外全国到處にあり

神佛参拝壽安全
七拾六度目乃礼
東京矢崎
栗山瀧々郎

（引ビラ）　刷物のよるに日本趣味廣告

三井呉服店は地方御得意様ながら御買物の
便利を謀り喩へば反物の品柄色合模様縞柄及
び代價の大要等御認めの上三井銀行又は其最
引銀行ある地は直為替又は郵便為替等まで
御送金相成候得は精々撰定仕り何方へなりと
も運賃さへ御拂御送り申上べくそろ
結婚禮其他数多御買物の節は演舩車到る
まで便利の今日御出京の工御来店下され候へ
ば御好み次第の品を取まき其代價の多寡に
よりて品物の良否なるも御置物よと比ぶれ
ば旅費などは忽ちに埋め合せ相成り貴賓の向
品物は飽くまで上等にして模様柄は飽くまで新
奇に注拍は色さめず仕立物は丁寧讀合に拙摸
模類は数多の畫工熱達して何んでも姿勢で相
認め夫れに直段の他より廉設も安貴なるは三
井呉服店の専賣を御證そろ

明治二十九年九月

本店　三井呉服店
東京市日本橋區駿河町
電話番錦五百貳百五番
　　　千貳百拾三番

支店　三井呉服店
大阪市東區高麗橋

看板の体系に属するゝ各態二十七種

看板の体系に属するす態各三十種

看板の体系に属するす各る態 (腰障子九種)

看板の体系に属する各態 (腰障子九種)

看板の体系に属する各態八種

看板の体系に属する各憲二十七種

染物類にょる廣告 (席亭造上幕)

染物類にょる廣告 (造上暖簾)

（各種幟）染物類によるも廣告

(ゝれのと板看) 態各備設告廣るけ於に前店

(ゝれのと板看) 態各備設告廣るけ於に前店

(えれのと根曾) 態各備設告廣るけ於に前店

(えれの上軒) 態各備設告廣るけ於に前店

繪ビラ各態十六種

繪ビラ各種十六種

聯合廣告的各見立繪ビラ

廣告的提灯各態

最新傾向広告集

23

Latest Trends in Advertising
Saishin keikō kōkokushū

PUBLISHED AUGUST 1930
23ʳᵈ RELEASE IN THE SERIES

The final release before lead editor Hamada Masuji's series-closing essay, this volume brings the compendium up to date with developments across Europe, focusing particularly on art deco and international constructivist designs using stylized abstraction, new typography, and photomontage. The volume underscores the editors' sense of urgency about keeping up with real-time global trends.

Many of the sampled designs suggest recognizable commodities or the human body but cloak them in abstracted shapes and geometric patterns to invite in the viewer's imagination (pages 402–3). Branding plays a prominent role, with companies like Waterman pens, Quinquina aromatized wine, and Madelios menswear joining the names of branded travel and leisure destinations like Finland and Tyskland (the Swedish word for Germany) as they project over decorative and landscape compositions (pages 404–5). Eastern European designs are rendered in the heraldic proletarian art styles emerging out of the Soviet Union, featuring muscled construction and factory workers engaged in physical labor (page 404, bottom right). Extra-bold display lettering and sans serif letterforms figure prominently throughout the volume.

Supplementing this extensive visual record, the essays discuss trends in display stand designs, as well as the expanding artistic sphere of mannequin design. While more conventional and lifelike mannequins dressed in new fashions were of course common in show window dioramas, the abstract humanoid mannequins shown here—rendered in gleaming metal with minimally delineated body parts—bring the styles of modern sculpture into the realm of commercial display (page 400). Writing after the historic launch of the first Japanese radio broadcasting company (JOAK, now known as NHK) in March 1925, the volume's authors conclude with ruminations on the future frontier of radio broadcast advertising.

(A) ボーグーの表紙　エドワルド・スタイヘン作（アメリカ）
(B) 化粧品の廣告　ロバート・ヨーカー（シヨーカード）オレナホルド（イギリス）
(C) 廣告畫　A・E・マルチヤル（アメリカ）
(D) 廣告畫　R・レイナルドル・サール（フランス）

歐米作家最近商業美術表現傾向（2）

最近のシカエスマ傾向の （3）

（B）最近のシカエスマ的なスプレ窓飾で効果的な光と示したるもの（ルセーヱシ男）

（A）新鮮奇抜なトビモ窓を得るたルセーヱシのシカエスマの裏表

LICHTQUELLE
LEUCHTE
BELEUCHTUNG

ehedem: Herdfeuer, Kienspan, Kerze, Petroleum – gering an Leuchtkraft! Heutige Lichtquelle: die Glühbirne – von vieltausendfach stärkerer Lichtstrahlung, das menschliche Auge blendend! – Das Licht der Glühbirne kann deshalb nicht so genutzt werden wie das der Kerze: es muß „abgeschirmt" werden. Dazu dient die Leuchte.

ehedem – als Kerzen-„Leuchter" oder Petroleum-Ampel – nur Lichthalter; heute: „Leucht"-Körper, nach lichtwissenschaftlichen Gesichtspunkten aus Glas oder Metall gefertigt; ihre Schirme lenken, zerstreuen, verteilen und sammeln das Licht der Glühbirne, damit das menschliche Auge es ertragen und nutzen kann. Die Leuchte spendet Beleuchtung.

ehedem nur Begriff für Helligkeit, zumeist erzielt durch unwirtschaftlichen Aufwand möglichst vieler Lichtquellen und „Beleuchtungs"-Körper; heute: gleichbedeutend mit intensiver, wirtschaftlicher und hygienischer Lichtausbeute, erzielt durch den sparsamen Einsatz lichttechn. richtig gebauter Leuchten.

LISA DUNCAN

PAUL COLIN

（スンラフ）作ンラコルーポ ータスボの踊舞

欧米最近商業美術表現傾向

作ケラーマドツレフルア ―ヌスポの行旅

向傾現表術美業商近最米欧

―キスサノロタ T 匠童び及装裝の本

向傾現表術美業商近最米欧

商業美術総論

24

Introduction to Commercial Art
Shōgyō bijutsu sōron

PUBLISHED SEPTEMBER 1930
24TH RELEASE IN THE SERIES

This final volume of the Ars compendium offers the most comprehensive expression of series editor Hamada Masuji's theory of commercial art, a hundred-page essay on the theoretical underpinnings of commercial design and the field's social implications. Embracing modernist fine art aesthetics together with industrial progress and mechanical production, Hamada's theory of commercial art also incorporates elements of popular psychology, visual perception theory, and Marxian social utopianism. For him, as "art with a purpose," commercial art performs an important service to society and will ultimately supplant fine art's effete mentality of art for art's sake.

Hamada's essay frames the entirety of *The Complete Commercial Artist* as both vehicle and expression of a new social status for design and designers in modern Japan. It begins by relating the birth of commercial art as a field to its historic naming as *shōgyō bijutsu*, soon followed by the establishment of the Commercial Artists Association under Hamada's leadership. It then gives a sweeping history of Western art from pyramids and cave paintings to cathedrals and modern art, arriving at an in-depth study of modernism as a transformative tool for commercial art. Hamada approaches the evocative strategies of autonomous abstract art as a means to serve the more clearly functional purposes of publicity and advertising.

Illustrations for his essay range across a wide field of modernist abstract art, from the Wassily Kandinsky painting that opens the volume (opposite page) to grids of work associated with movements such as De Stijl, suprematism, constructivism, Dada, and futurism (pages 408–11). He draws many of them from Bauhaus publications, such as László Moholy-Nagy's 1929 *From Material to Architecture* (*Von Material zu Architektur*). They also embrace modern machines and structures (pages 412–13), including buildings by Le Corbusier (page 413, top left), whose vision of architecture's practical purpose Hamada incorporates into his account of commercial art. A bibliography following the essay reveals a breadth of intellectual references, from Russian and German Marxists such as Anatoly Lunacharsky, Moisei Ginzburg, and Georgi V. Plekhanov to Japanese art critics and social theorists including Kurahara Korehito, Moriguchi Tari, and series contributor Murayama Tomoyoshi.

A translation of the concluding section of Hamada's textual and visual manifesto, which provides the essence of his vision, appears on pages 414–18.

抽象表現主義繪畫　　カンデンスキー筆

ダダイスティシュな作品から商業美術の造型作品へ

(A) クルト・シュビッテルスの試み——『廃棄されたもの』の形から合質物成形態作品(一九二二年)
(B) モホリ・ナーギーの試み 立體的作品「シ」浮彫しての憶念(一九二〇年)
(C) 日本に於けるダダ的作品深青島作(一九二五年作)或日の思出』絵畫
(D) 陳列装置用造形稻垣知雄作(一九二九年日本商業美術展出品)——物質綜合的な語例——ダダイスティシュな道程に於て買用に見出さるれ

幾何學的抽象表現主義作品

(A) デ・スチイル派のファン・ドウズブルグの繪畫（一九二九年）
(B) エル・リシツキーのスケッチ的作品（一九二九年）
(C) アルキペンコのW・聖オクタシヌス一九一一年
(D) グレーズのシェーメトリア（一九二九年）

構成主義作品と商業美術の構成

(A) エル・リシツキーの構成主義作品
(B) 貨物スタンプの構成主義作品
(C) 物品の構成木材スタンプ用紙
(D) ガードナースト・エフスの構成主義作品
(E) 徹底せる構成主義作品の写真

新彫刻的意図の開拓マキシキンヘ藝術の暗示

(A) アーキペンコ（一九二七年）人體を巻き戰き成なかし組造物たり想造を
(B) エストラクチュラしてまに繪とるも型
(C) サイエンテニスの作品（一九二九年）
(D) ガブアンドペエキヴアンの製作の暗示

立體の造型商業美術への道

(A) 内部圖ガブアンドペエキヴア作 成碁の碁盤が碁石を置かれの體制（一九二四年）
(B) 機械的ベーローの物品擺風なしとも試み
(C) 彼作圖監査判定が（一九二九年博覧会出品）問連の作告

寫眞の構成形態

(A) モホリ―ナギーの構成 (一九二二年) この作品のアイデアから現在のフォトグラムやニ重三重露出寫眞の概念が引き出されてゐる
(B) 構成寫眞による廣告用形態
(C) 寫眞的彫刻 (フォトグラスツク)

A

B

構成主義の實用的方向

(A) 室内の装飾的方向さしての例 エルシリキー作　(B) 同・リートフェルド作 (一九二三年)

新時代を語る機械美
―部分な密緻力一杯を見べしと驚嘆―

新時代を語る機械美 (構造的の美しさ)

(A) 新汽船レヴアイメーシンの雄姿
(B) 一九二九年型の最新機関車
(C) 最新型自動車形態
(D) ドアイ最新式車輛美
(E) 飛行機の美しさ

新時代を語る合理的建築美

(A) ル・コルビュジエの設計になる新住宅　(B) ブランクフルトにて建られたる集合住宅
(C) ニールンベルゲにおけるコークヒー店クラウス統機　G・シュツアイフェルト設計　(D) モスクワにおける工場クラブ　K・メニニコウ設計

新時代を語る工作品の傾向（単純と合理的）

(A) 事務用卓　(B) 椅子　(C) 食器類

FROM "INTRODUCTION TO COMMERCIAL ART"
BY HAMADA MASUJI

The concluding section of Hamada Masuji's "Introduction to Commercial Art," translated here by Magdalena Kolodziej, originally appeared in volume 24 of The Complete Commercial Artist *(1930), pages 88–91.*

THE DEVELOPMENT AND FUTURE OF COMMERCIAL ART

In conclusion, commercial art has emerged from the disintegration of art and the aestheticization of commerce. I have previously discussed the style and aesthetics of commercial art. Now, what about its development? Since commercial art is art with a purpose, it pertains to pragmatically useful activities—but is that all? The reason commercial art constitutes a new and definitive art is that it has fully united the actual form of commerce—which is not commercialism, as in its true form commerce is simply distribution to many people—with the newly conceived form of production art: Commercial art becomes productive and simultaneously resists power when it merges commerce and production art and moves them toward spiritual elevation.[1] An art that is truly useful to society is thereby created, and the power of art manifests itself to society for the first time.

This may appear difficult to understand but can easily be elucidated with further explanation.

Beauty borrows the form of produced objects so that it can reach the masses. In other words, posters, display windows, products, stage design, and printed matter—all these things created for a purpose—are imbued with beauty that people can perceive through their senses. Display windows are beautiful, cars are beautiful, plates and containers are beautiful; they are endowed with a beauty resplendent to people (which is nevertheless also productive).

Le Corbusier's words on industrial aesthetics and architecture can be applied to all produced objects:

> "An architect satisfies our senses and activates a feeling of form. Similarly, he creates an echo in our hearts, shows us the order that should exist in this world, appealing to both our feelings and understanding. Indeed, through him, we sense beauty for the first time."[2]

In other words, we are able to extract a sense of beauty from all things. Thus, when beauty is distributed in commercial form, it is distributed to the largest number of people. This is because commerce, which deals with the masses, is designed for widespread distribution. Moreover, commerce aspires to spiritual elevation. Therefore, the intention of its products has to concomitantly conform to the goal of spiritual elevation. In this case, spiritual elevation signifies the socialization of commerce and the recognition of life's value.[3] In this way, all produced objects become elegant, refined, and dignified. The spirit of the artist and his aim become gradually purified. Members of society encounter many such objects and through

them become spiritually purified. In such cases, the productive arts have a religious effect and bring about change. What is more, nobody can affect this process, no matter what their class or authority. People are inspired by the way in which beauty fuses the artist's spirit with his goals.

This situation is unprecedented.

In the era of royalty, there was royal art, and art existed at the will of the royalty. In the era of religion, art was Christian or, for instance, Buddhist, and functioned to agitate (for the purposes of propaganda or edification). In the era of aristocracy, art existed at the will of the aristocracy and took the form of pleasurable consumption. It was the same in bourgeois society. Until today, there has been no art that has occupied its own independent position and existed purely at the will of the artist's spirit, which takes the heart of the masses as its own.

However, such an art can now be realized.

Indeed, art today has removed itself from the irrationality of the ruling classes and become an art of the people and of artists for the very first time.

We might then ask, "In what form does such an art appear?" It reflects the mood of the masses and is produced in a fashionable form because the attitude of the masses directly defines the form of manufactured products. The fashionable products themselves constitute today's new form of art.

In bourgeois society, individualist, consumption-oriented art was the ruin of these fashionable products. They were indeed irrational, without purpose—that is, they were products of fashion purely for fashion's sake. Yet, in our current production-oriented society, these fashionable products have assumed a rational, purposeful, necessary form; this is to say, anticipating an ideological decision based on universal need and inevitability, they have emerged as a kind of biology.[4] In other words, they were produced in conformity with economy, physiology, machine, and spirit.

Yet, is our world full of rational and formalized forms? In fact, commercial art is quite complicated. Only commercial art based on psychological properties can break this anxiety of a world filled solely with rational and formalized forms. Commercial art based on psychological properties is a form of art related to advertisement, performance, and popular entertainment. Different from architecture and other related material objects, it is based on the structure of human psychology. Therefore, as the structure of human psychology changes, so do the products of its expression. Psychology changes constantly. As long as commercial art accommodates this change, there are no limits to how much it can change. Human life certainly does not suffer from monotony. The fact that commercial art is transformed due to the structure of human psychology and can manifest itself in any number of ways is in and of itself the production of beauty. That is, we can call this a production of form.[5] This phenomenon also occurs today. Today, society is complicated, and the classes are divided along many lines. For that reason, today's movies, performances, and commercial art in fact represent and manifest a diverse class system. Bourgeois art, bourgeois fashionable products, bourgeois movies, proletarian art, proletarian fashionable products, proletarian movies, erotic art, erotic fashionable products, erotic movies, ultramodern fashionable products, ultramodern movies, classical art, classical fashionable products, genre movies, etcetera—these forms are like geological strata that reveal the composition of each era.

However, if in our times we are moving toward the gradual solidification of a classless society, the outward appearance of our products will also gradually move in the direction established by the form society takes. As a result, a form of creativity that corresponds to society will emerge from within it.

In order to discuss the future of commercial art, I will first explain its class system; that is to say, its affiliation.

CLASS IN COMMERCIAL ART

[…] It is clear to whom the art of the production system belongs. The production system represents the will of the subjugated class. For that reason, as long as art maintains consciousness toward its production, it will remain an art of the masses.

However, when the term "commercial art" is employed, despite the fact that the notion refers to the production system, because of the word "commerce" there is a tendency to hastily interpret it as an art of capitalism. This objection arises from a total misunderstanding of the standpoint of production art. Of course commercial art emerged as a means of capitalist commerce. Yet it also emerged from today's form of labor and today's machines, and these things are not considered representative of capitalism. The irrationality of capitalism lies in its form of exploitation. The efficiency of labor and machines serves the purposes of capitalist exploitation, yet the efficiency, if we treat it separately from the capitalists, constitutes a new value for the form production takes in society. Even if we lived in an entirely proletarian society, we could not get rid of machines and labor completely, and so we cannot dispense with the notion of efficiency.

Put simply, the irrationality appears in the fact that the authority of exploitation lies in the hands of the capitalists; efficiency itself is not dependent on class. In other words, no matter how it is assigned, labor itself is necessary in any society. Similarly, no matter the cause of its emergence, the form commercial art itself takes, as far as it is related to production, does not involve the class system. The irrationality lies in the exploitation. This is because unjust accumulation invariably occurs as a result of exploitation, and unjust accumulation leads to unjust and aimless consumption. The art of capitalists is that which only serves this unjust and aimless consumption.

Explained simply, if there is a metalworker who produces a headdress for an aristocratic woman, even if this headdress is a bourgeois necessity, the metalworker is by no means bourgeois. Similarly, when a capitalist uses a poster designed by a poster artist as a means of exploitation, that artist is not bourgeois. He is an artist worker.

In each of these cases, what is being produced is merely something with an aim. And, for these workers, no matter what the product they are producing might be, whether it is for consumption (a decoration of surplus value) or production (a tool or implement), it does not bear a strong assertion of the maker's own persona. Put simply, the maker creates it in response to a demand and only for the purpose of this demand. However, by comparison, in the case of a pure artist, the work produced will bear a strong assertion of the maker's own persona. The work is his alone. Moreover, he engages in providing objects for consumption, which is enabled by bourgeois exploitation.

It is not the metalworker but the merchant who supplies the headdress made by the metalworker to the market. This is an example of commercial capital. There is no gain for the metalworker. Similarly, it is the merchant who places the poster in the market,

not the poster artist himself. The artist receives no direct profit from this poster. He only receives wages as profit for his labor. Yet, in the case of the pure artist, he supplies the market directly. Moreover, his aim is consumption—that is, it reflects bourgeois ideology. Here class affiliation becomes clear.

The commercial artist does not depend on bourgeois ideology. He is only involved in production.

If a revolution in society were to occur in which the need for irrational bourgeois production—that is, unjust accumulation demanding purposeless consumption—were to disappear, then these artists would become producer artists and their work would inevitably turn to production forms.

Sure enough, modern society is constantly demanding that we bear a consciousness toward production and the masses. Indeed, commercialism itself is not a widespread principle anymore because the influence of machine production advances things that are of mass value. This being the case, rather than producing art for the sake of commercialism, mass art is produced.

Bourgeois society has completely perished in Russia, and for that reason there you find production artists and production art, thereby confirming the present form of proletarian art. However, in other societies and countries, commercialism hastily advances its form. It moves rapidly toward a vigorous mass art of commercialism. For instance, America increasingly pursues commercialism via industrial capitalism and advances its form of production with an emphasis on the masses and the production itself. Production art is most developed in America. That is, all the machine-manufactured products, advertisements, movies, and fashions are dazzling. We find most rapid change to be happening there. In Russia, because of the revolution in consciousness, a purposive art needed for class struggle is being created. Art there exists as a weapon in the proletarian struggle, which relies on the power of agitation. Also, it dictates art that privileges form and defines proletarian life: for instance, simplified rational architecture and rational machines.

Bourgeois ideology and consumption ideology are pervasive in America. For that reason, art with purpose, such as movies and entertainment, can be found to exhibit an increasingly nonsensical and degenerate character. Inasmuch as the present social structure of America demands them, it is because America is a capitalist country; in Russia, even movies are weapons for class struggle.

Production art has been forgotten for many years; if one were to design a world in which it prevails, one must employ the accelerated speed of distribution as much as possible. Today, systems of commercial distribution make use of distribution's accelerated speed. In response to more rapid production, commerce in turn demands the acceleration of distribution. In order to accelerate distribution, commerce increasingly demands beauty. It pursues the masses without pause for breath. If one were to try to thoroughly popularize art and bring it out into the everyday world, wise policy would make good use of today's commercialism, thereby providing society as a whole with an art that borrows from the form of production. In adopting the designation of "commercial art," art can therefore acquire true legitimacy.

Were he to press such a principle of accelerated distribution, a producer could transform his own world. Distribution unconsciously, yet inevitably, brings change to the world. Herein we see how

global transformation might peacefully take place.

It is the machine, that fearsome act of production, that has taught us this truth. If we approach the machine act as a form of action, great results can be expected when we engage our creativity.

The term commercial art refers to a newly constructed world of spirit (art) that takes as its precondition machine (industry) and distribution (commerce), which it uses as its weapons. Commercial art encompasses the production, the machine, and the planning of distribution. However, its ultimate aim is to build a rapturous world of beauty for the happiness of people's lives. Such beauty is not limited to a select class: It exists for the entire human race.

CONCLUDING REMARKS

In conclusion, with the advancement of civilization in the present, we have discovered production art and learned that commerce must develop in the direction of art. It is thus that a new spirit of commercial art has been born.

If the spirit of commercial art is merely about advertising and commercial exploitation, it will soon perish. We engage with advertising as part of commercial art, because we view it primarily as a means to accelerate distribution.

Whether it be through production, advertisement, or distribution, commercial art allows the beauty of new art to reach the masses widely and quickly. In this way, all things become delightful, all things bring joy, and all things find their proper way in peace.

ENDNOTES

[1] Hamada often uses terms such as production art (*seisan bijutsu*) or productive arts (*seisanteki geijutsu*) as synonyms for commercial art (*shōgyō bijutsu*). His emphasis on the aspect of production throughout this essay indicates his particular understanding of commercial art as art that belongs to the era of mass productivity and whose subject is the proletariat.

[2] Le Corbusier (1887–1965), or Charles-Édouard Jeanneret-Gris, was a Swiss-French architect and urban planner. As a foundational figure in the modernist movement, he was widely read in Japan. The quotation above is a translation from the Japanese. Hamada does not provide a source, but it seems to have been taken from Le Corbusier's influential *Towards a New Architecture*, which first appeared in 1923: "The Architect, by his arrangement of forms, realizes an order which is a pure creation of his spirit; by forms and shapes he affects our senses to an acute degree, and provokes plastic emotions; by the relationships which he creates he wakes in us profound echoes, he gives us the measure of an order which we feel to be in accordance with that of our world, he determines the various movements of our heart and our understanding; it is then that we experience the sense of beauty" (Le Corbusier, *Towards a New Architecture*, trans. Frederick Etchells [New York: Dover, 1986], 11).

[3] Hamada uses the word socialization in its secondary and less common meaning: that is, making something socialistic.

[4] Hamada uses a German word, *Biologie*, written in *katakana* for "biology."

[5] Hamada uses the word form, which appears to be borrowed from German, in *katakana*.

SELECTED BIOGRAPHIES

The Commercial Artists Association, circa 1926.

新井泉
ARAI SEN (1902–1983)
Commercial artist, critic, researcher
Born in Kanagawa Prefecture

Arai studied at the Tokyo School of Fine Arts. After graduating, he worked as a design manager for the Toppan Printing Company before establishing his own studio in 1926. A founding member of the Group of Seven (Shichininsha) design study association, he also played an establishing role in the Commercial Artists Association (Shōgyō Bijutsuka Kyōkai), a group closely involved in *The Complete Commercial Artist* (*Gendai shōgyō bijutsu zenshū*; hereafter abbreviated *TCCA*). In the 1930s, Arai taught at Tama Imperial Art School (Tama Teikoku Bijutsu Gakkō; now Tama Art University), coauthored two volumes on poster design, and took part in editing the journal *Desegno*. After the Second World War, Arai taught at Joshibi University of Art and Design and at Kyūshū Sangyō University while continuing to publish books and essays, including his research on pattern design.

Arai contributed one essay on signboard design to *TCCA*. For artwork by Arai, see pages 31, 197, and 299.

藤澤龍雄
FUJISAWA TATSUO (1893–1969)
Commercial artist, children's illustrator
Born in Kanagawa Prefecture

Fujisawa studied industrial design at the Tokyo Higher Technical School. He worked as a poster artist and print designer for packaging and candy companies before opening his own studio. A prolific designer and illustrator whose work appeared in numerous books and magazines for children, he served as design manager of the magazine *Shop World* (*Shōtenkai*, also known as *The World of Popular Stores*), which disseminated marketing information and commercial art ideas for retailers. One of the founding members of the Commercial Artists Association in 1926, Fujisawa was later involved in establishing the Association of Practical Print Arts (Jitsuyō Hanga Bijutsu Kyōkai) in 1929.

Fujisawa contributed three essays to *TCCA* on poster design, color selection for show window backgrounds, and wrapping paper design. For artwork by Fujisawa, see title page and pages 65, bottom; 66, bottom right; 103, top right; 194; 224; 292; 295; and 316, bottom.

Hamada Masuji, circa 1920s.

濱田増治
HAMADA MASUJI (1892–1938)
Commercial artist, design critic, editor, educator
Born in Hyōgo Prefecture

Hamada grew up in Osaka. He studied Western-style painting at the studios of the White Horse Society (Hakubakai) and the Pacific Painting Society (Taiheiyō Gakai). He then started a degree in sculpture at the Tokyo School of Fine Arts while

publishing cartoons and illustrations on the side. In the late 1910s and early 1920s, Hamada designed promotional material for the toothpaste company Lion Dentifrice, as well as for Yokohama Rubber and the Hiromeya advertising agency. He also earned recognition for his art criticism and newspaper illustrations. In 1924, he became an editor for the magazine *Advertising and Display* (*Kōkoku to chinretsu*), which soon relaunched as *Advertising World* (*Kōkokukai*). He founded the Commercial Artists Association with a group of distinguished colleagues in 1926. As its director he organized yearly exhibitions and played a formative role in the professionalization of design in Japan. *The Complete Commercial Artist* reflects the height of these efforts. Following its completion in 1930, Hamada founded and edited a new periodical, *Commercial Art* (*Shōgyō bijutsu*); established his own School of Commercial Art (*Shōgyō Bijutsu Kōsei Juku*); and published a series of instructional books, including the two-volume *Commercial Art Textbook* (*Shōgyō bijutsu kyōhon*; 1936) and the five-volume *Lectures on Commercial Art* (*Shōgyō bijutsu kōza*; 1937–1938).

The principal member of *TCCA*'s editorial committee, Hamada contributed thirty-two essays to the series—the most of any contributor. These appeared in all but one volume and culminated in his volume-length "Introduction to Commercial Art." For artwork by Hamada, see pages 12; 35; 38; 40; 61, center; 66, bottom left; 92; 94, top; 96; 101, bottom; 115, bottom; 134–35; 141, top left and right; 154, bottom left; 156, top left; 180, top left and bottom; 181–85; 191; 192, top left; 193, bottom; 195, bottom left and right; 202, top right; 203, bottom; and 409, bottom right.

石本喜久治
ISHIMOTO KIKUJI (1894–1963)
Architect
Born in Kobe, Hyōgo Prefecture

While studying architecture at Tokyo Imperial University, Ishimoto helped found the Secessionist Architecture Association (Bunriha Kenchikukai), a group devoted to modern architectural styles and practices. In 1922, he traveled to Europe, where he studied at the Bauhaus in Dessau and gathered materials for a 1924 book on architectural trends abroad. Ishimoto designed several important buildings in Japan, including the *Asahi Shimbun* office and the Shirokiya department store. He began teaching at Kyoto University in 1927 and in the same year established the Kataoka-Ishimoto Architectural Studio with architect Kataoka Yasushi. Renamed the Ishimoto Architectural and Engineering Firm after Kataoka's retirement, its projects ranged from innovative domestic dwellings to the headquarters of the Nippon Typewriter Company.

For artwork by Ishimoto, see page 190.

蔵田周忠
KURATA CHIKATADA (1895–1966)
Architect, architecture critic and historian, product designer
Born in Hagi, Yamaguchi Prefecture

Kurata studied architecture at Kōshu Gakkō (now Kogakuin University) and Waseda University. From 1922 to 1945, he served as a lecturer at the Tokyo Higher School of Arts and Technology (Tōkyō Kōtō Kōgei Gakkō). Kurota wrote, compiled, and edited a number of significant books and articles, dealing especially with European modernist trends and figures such as Walter Gropius, with whom he studied in Berlin between 1930 and 1931. A prominent member of the Secessionist Architecture Association, he helped found the Keiji Kōbō

design workshop, an enterprise devoted to the production of standardized modern furniture, in 1928. He later founded an architectural office and became a professor at the Musashi Higher Technical School.

For artwork by Kurata, see page 72.

前川千帆
MAEKAWA SENPAN (1888–1960)
Manga artist, woodblock artist
Born in Kyoto

Maekawa studied at the Kansai Fine Art Academy with painters Asai Chū and Kanokogi Takeshirō. He moved to Tokyo in 1911 and began drawing cartoons for the satirical magazine *Tokyo Puck* (*Tōkyō pakku*). Over the next two decades, Maekawa found success as both a commercial illustrator and a comic strip artist, whose *Scatterbrained Mr. Bear* (*Awatemono no Kuma-san*) ran in the *Yomiuri Sunday Manga* between 1930 and 1933. Maekawa also earned renown as a woodblock artist. A leading figure of the creative prints (*sōsaku hanga*) movement, he played an active role in the Japan Print Association (Nihon Hanga Kyōkai) from 1931 to 1960, and his prints drew global interest, especially in the years following the Second World War.

For artwork by Maekawa, see pages 32, top; 254; and 259, top left.

宮下孝雄
MIYASHITA TAKAO (1890–1972)
Commercial artist, design theorist, educator
Born in Tokyo

Miyashita studied at the Tokyo Higher School of Arts and Technology. In addition to pursuing design work, contributing to magazines, and judging major competitions, he taught at multiple institutions, including his alma mater, where he served as a professor of industrial arts from 1922 to 1944. Miyashita is best known as the author of books on color theory, European pattern design, clothing, camouflage, and design practices.

A member of the *TCCA* editorial committee, Miyashita contributed ten essays to the series, discussing poster composition, book design history, modern trends in newspaper and magazine layout, and other topics. For artwork by Miyashita, see page 111.

宮尾しげを
MIYAO SHIGEO (1902–1982)
Manga artist, researcher
Born in Tokyo

At age 17, Miyao undertook private study under famed manga artist Okamoto Ippei. In the 1920s, Miyao drew comic strips and political caricatures for newspapers and published influential children's manga stories. Later in his career, he devoted significant energy to the study of Japanese cultural traditions, publishing books on folk culture and the history of illustrated texts.

For artwork by Miyao, see page 258.

Murayama Tomoyoshi, circa 1925.

村山知義
MURAYAMA TOMOYOSHI (1901–1977)
Artist, playwright, illustrator, novelist, cultural critic
Born in Tokyo

Largely self-taught as an artist, Murayama spent a year studying philosophy at Tokyo Imperial University, then three months as an art student at the conservative Pacific

Western-Style Painting Studio (Taiheiyō Yōga Kenkyūjo). In 1922, he traveled to Berlin, where he became involved in avant-garde circles and developed an aesthetic practice informed by anarchist and Marxist political thought, as well as by expressionism, futurism, constructivism, and other oppositional artistic tendencies. Returning to Japan the next year, he produced work under the banner of conscious constructivism (*ishikiteki kōseishugi*) and founded the avant-garde group Mavo with four colleagues. A multidisciplinary artist, Murayama wrote and produced leftist theatrical productions, exhibited mixed media assemblages, published novels and books of criticism, illustrated children's books, and undertook commercial art projects. Avidly involved in proletarian art organizations, Murayama faced police suppression and arrest in the 1930s. During the Second World War, he was held in solitary confinement for two years and prohibited from practicing art. After the war, Murayama devoted much of his creative energy to writing for, producing, and teaching theater.

For artwork by Murayama, see pages 68; 107; and 142, top.

室田久良三 (A.K.A. 室田庫造)
MUROTA KURAZŌ
(ACTIVE CIRCA 1920–CIRCA 1966)
Commercial artist

Early in his career, Murota worked in the advertising department for the Morinaga confectionery company. After winning a newspaper advertising competition in 1926, he took a job with the Seibundō publishing company and soon became editor in chief of the magazine *Advertising World* (*Kōkokukai*), a position he held until 1935. While involved with the magazine, he published numerous articles about commercial art and issued bound collections of design examples. Murota took part in founding the Commercial Artists Association in 1926.

For artwork by Murota, see pages 34 and 151, top right.

仲田定之助
NAKADA SADANOSUKE (1888–1970)
Art and design critic, sculptor, visual artist
Born in Tokyo

After dropping out of school, Nakada worked for a general trading company. He then began a career as a newspaper writer, eventually establishing himself as an art reporter for Tokyo's *Asahi Shimbun*, one of the largest newspapers in Japan. In 1922, he traveled to Germany and visited the Bauhaus. A prolific art writer throughout the 1920s and '30s, he wrote articles for *Mavo*, *Atelier*, *Mizue*, and *Asahi Camera* addressing avant-garde practices in Europe and promoting artistic experimentation. He exhibited sculptural work as part of the anti-establishment artist group the Third Section (Sanka). Nakada served as managing committee member of the Commercial Arts Association. Shortly before his death, he published an award-winning two-volume study of the professional customs and everyday life of Meiji-era Tokyo.

A member of the *TCCA* editorial committee, Nakada contributed five essays to the series, discussing Bauhaus lettering, modernist photography, book design, and Hungarian designer Lajos Kassák. For artwork by Nakada, see pages 31; 65, top; 245; and 248.

岡本一平
OKAMOTO IPPEI (1886–1948)
Manga artist, writer
Born in Hakodate, Hokkaido Prefecture

Okamoto studied Western-style painting with influential artist Fujishima Takeji at the Tokyo School of Fine Arts. After a stint

designing sets for the Imperial Theater, he began publishing social and political cartoons in the Asahi Shimbun in 1912, soon earning fame as a manga journalist (*manga kisha*). Over the following decades, he contributed comics to a wide range of magazines, published multiple manga volumes, and became an important proponent of his craft. Okamoto took part in founding the Association of Tokyo Manga (Tōkyō Manga Kai) in 1915 and soon after established a private school for manga artists.

For artwork by Okamoto, see page 251.

恩地孝四郎
ONCHI KŌSHIRŌ (1891–1955)
Woodblock artist, book designer, poet
Born in Tokyo

Onchi was the son of a creative woodblock artist and photographer. Following his early training in the arts, he studied oil painting and sculpture at the Tokyo School of Fine Arts and received an informal education under illustrator and print designer Takehisa Yumeji. A prominent figure in Japan's creative prints (*sōsaku hanga*) movement, Onchi explored the woodblock medium's potential for abstraction and modern expression in print collections, books, and exhibitions. He was also a successful and prolific book designer, responsible for hundreds of unique cover designs. He helped launch and edit several important art, design, and poetry journals, including *Tsukuhae* (Moonglow; 1913–1915), *Kanjō* (Sentiment; 1916–1919), *Naizai* (Immanence; 1921–1922), and the book design magazine *Shosō* (1935–1944).

Onchi contributed one essay on cover design to *TCCA*. For artwork by Onchi, see page 222, top.

齋藤佳三 (A.K.A. 斎藤佳三)
SAITŌ KAZŌ (1887–1955)
Multidisciplinary artist, commercial artist, composer
Born in Akita Prefecture

Saitō studied at the Tokyo Music School and then enrolled in the design department of the Tokyo School of Fine Arts, where he would later teach design courses. After a 1912 trip to Germany, where he met artists of the avant-garde, Saitō helped mount a 1914 exhibition of expressionist woodcuts in Tokyo, wrote articles about artistic trends in Europe, and began advocating for the interdisciplinary practice of what he called synthetic art (*sōgō geijutsu*). A prolific creator across a range of art forms and media, Saitō produced music, costumes, scripts, and sets for theatrical performances; illustrated magazine and sheet music covers; and designed colorful, rhythmic textile patterns and women's clothing.

For artwork by Saitō, see page 193, top.

宍戸左行
SHISHIDO SAKŌ (1888–1969)
Manga artist
Born in Fukushima

After completing his early education, Shishido traveled to the United States, where he studied painting at the Cannon Art School in Los Angeles and completed correspondence courses in cartoon illustration. He returned to Japan after nine years and began drawing political comics for Tokyo-based newspapers. Shishido took part in the founding of the Japanese Manga Association in 1923. Best known for his influential cartoon strip *Speedy Tarō* (*Supīdo Tarō*; 1930–1933), Shisido is credited with pioneering new narrative approaches to the medium.

For artwork by Shishido, see page 259, top right.

Sugiura Hisui, circa 1930s.

杉浦非水
SUGIURA HISUI (1876–1965)
Commercial and graphic artist
Born in Matsuyama, Ehime Prefecture

Sugiura studied with two leading practitioners of Japanese-style painting before enrolling at the Tokyo School of Fine Arts, where he trained with Kuroda Seiki. Among the most influential and prolific Japanese graphic artists of his time, Sugiura is best known for the posters and print material he created while serving as chief designer at the Mitsukoshi department store, a position he held from 1910 to 1934. He designed hundreds of original book and magazine covers, iconic product packages, and decorative motifs, developing a signature style that drew upon art nouveau, poster art, and Japanese graphic forms. He traveled to Europe in 1922 and, one year after returning to Japan, founded the Group of Seven design study association in 1925. His association held yearly poster shows and in 1927 launched Japan's first graphic design magazine, *Affiches* (*Posters*). In 1929, Sugiura became head of the design department at the Imperial Art School, and in 1935, he helped establish the Tama Imperial Art School, where he later served as president.

A member of *TCCA*'s editorial committee, Sugiura contributed one essay on Parisian theater posters to the series. For artwork by Sugiura, see pages 19–21, 64, and 150.

多田北烏
TADA HOKUU (1889–1948)
Commercial artist, illustrator
Born in Matsumoto, Nagano Prefecture

Tada studied at the Tokyo Higher School of Arts and Technology and at the Kawabata School of Painting. He worked in the design department of the Toppan Printing Company before founding Sun Studio in 1922. A prolific designer of print advertisements and posters (including many for the Kirin beer company), Tada was a member of the Commercial Artists Association from its inception in 1926. In 1930, he helped establish the Association of Practical Print Arts (Jitsuyō Hanga Bijutsu Kyōkai) and became its director. A frequent contributor to the magazines *Shop World* (*Shōtenkai*) and *Advertising World* (*Kōkokukai*), Tada assumed editorial responsibilities at the latter publication in the 1930s. He was also a successful children's illustrator.

Tada contributed one essay on poster design to *TCCA*. For artwork by Tada, see page 78.

A young Takehisa Yumeji, undated.

竹久夢二
TAKEHISA YUMEJI (1884–1934)

Commercial artist and illustrator, woodblock artist, painter, poet
Born in Oku (now Setouchi), Okayama Prefecture

Largely self-taught, Takehisa began his career as an illustrator around 1905. Many of his early illustrations appeared in the newspaper of the Common People's Association (Heiminsha), a socialist and antiwar organization that he remained associated with until 1910. Beginning in 1909, he published a popular series of book-length collections that combined his visual work with poetry and other writings. His illustrations and woodblock prints, particularly of women depicted in his signature minimal yet romantic style, appeared in countless newspapers, magazines, and literary journals. In a Tokyo shop he maintained with his wife, Takehisa sold postcards, prints, and a range of products of his own design while providing a gathering and learning space for younger illustrators and woodblock print artists. From 1931 to 1933, he traveled to Europe, where he lectured at the art school of former Bauhaus professor Johannes Itten. Today, six museums in Japan are dedicated to his work.

For artwork by Takehisa, see pages 321, bottom left and right and 364, top right.

Takei Takeo, 1952.

武井武雄
TAKEI TAKEO (1894–1983)

Illustrator, book artist, woodblock artist, commercial artist
Born in the village of Hirano (now Okaya), Nagano Prefecture

Takei studied Western-style painting at the Tokyo School of Fine Arts. One of the most influential children's illustrators of his time, he produced art for numerous stories by Japanese and European authors, as well as many works from his own imagination. In 1922, he helped establish the popular magazine *Children's Country (Kodomo no kuni)*, and in 1931 he became its editor. Takei also founded the Japanese Children's Art Association (Nihon Dōga Kyōkai) in 1931 and played a leading role in the development of new children's literature through his work with the organization. From 1935 until his death, Takei produced 139 inventive artist books, each exploring distinct materials and methods of production.

For artwork by Takei, see pages 110, bottom, and 242, top right.

田附与一郎 (A.K.A. 田附與一郎)
TATSUKE YOICHIRŌ (ACTIVE AFTER 1920)

Advertising professional and researcher

Early in his career, Tatsuke managed the advertising department of a prominent yarn manufacturer. He later established his own firm and managed the sole Japanese distributor for a French mannequin company. Tatsuke served as director of the Japanese Advertising Study Association

(Nihon Kōkoku Gakkai), and in 1926 he published an extensive survey of Western commercial posters.

A member of the *TCCA*'s editorial committee, Tatsuke contributed five essays to the series, including a review of European posters and a bibliography of Western materials on book design.

渡辺素舟
WATANABE SOSHŪ (1890–1986)
Historian of art, crafts, and literature
Born near present-day Kiyosu, Aichi Prefecture

Watanabe studied Chinese and Japanese literature at Toyo University (Tōyō Daigaku). He wrote important historical studies of Japanese craft production and East Asian literature, as well as many articles on design and art exhibitions. He is especially known for his systematic research on pattern design. Over the course of his long teaching career, Watanabe held posts at the Imperial Art School, the Tama Imperial Art School, and the Tokyo Higher School of Arts and Technology.

A member of the *TCCA* editorial committee, Watanabe contributed two essays on poster art and street sales decorations to the series.

矢島週一 (A.K.A. 矢島周一)
YAJIMA SHŪICHI (1895–1982)
Lettering and poster designer
Born in Gifu Prefecture

Yajima worked at a printing company based in Osaka before founding an independent design studio in the 1920s. In 1928, he helped establish the Osaka Commercial Artists Association, a sister organization of the Commercial Artists Association. Yajima is best known for two books on lettering design, *Typographic Handbook* (*Zuan moji taikan*) and *Anatomy of Design Letters* (*Zuan moji no kaibō*), published in 1926 and 1928, respectively. Issued in multiple editions and still available today, these books offered systemic presentations of a vast range of lettering styles and explored geometric and modular methods of character construction.

Yajima contributed three essays to *TCCA* on utility pole signs, the history of writing, and contemporary methods for designing letters. For artwork by Yajima, see pages 24–25; 141, bottom right; 151, top left; and 286.

山口文象 (A.K.A. 岡村蚊象)
YAMAGUCHI BUNZŌ (A.K.A. OKAMURA BUNZŌ) (1902–1978)
Architect
Born in Tokyo

Yamaguchi was the son of a master carpenter. After beginning a career in construction, he became a drafting technician for the Japanese Ministry of Communications. He joined the Secessionist Architecture Association in 1921 and two years later helped found the Creation of the Universe Society (Sōsha), a group of architects and engineers committed to modernist building principles and design. As a leading voice of the organization, Yamaguchi promoted a Marxist vision of architectural modernism. He played a role in reconstruction efforts following the Great Kantō Earthquake of 1923, undertaking various civil engineering projects. In 1930, Yamaguchi traveled to Europe, where he worked in the Berlin office of Bauhaus founder Walter Gropius. Returning to Japan in 1932, he opened his own office, which after the Second World War evolved into the Research Institute of Architecture (RIA). His notable projects included large institutional buildings, such as the Nihon Dental College Hospital (1934), as well as modern wood-clad houses.

For artwork by Yamaguchi, see page 188.

INDEX

A

advertisements
 with electricity, 158, *159–75*
 flyers, 310, *311–23*
 in Japanese taste, 374, *375–97*
 latest trends in, 398, *399–405*
 in newspapers and magazines, 234, *235–43*
 with photography and cartoons, 30–32, 244, *245–61*
advertising letters (*kōkoku moji*), 44 (note 36)
Advertising World (*Kōkokukai*), 33, 34, 420, 422, 424
Affiches (*Posters*), 20, *21*, 44 (note 31)
Ajinomoto seasoning, 234, 324
Akadama port wine, 234, 262, *285*
Albers, Josef, 26
Altman, Natan, 37
anomalous letters (*hentai moji*), 44 (note 36)
Arai Sen, 31, 419
archways, 186
Ars (publisher), 10, 43 (note 3), 130, 186, 310
art deco, 14, 19, 398
art nouveau, 14, 19, 20, 25, 48, 424
L'art vivant, 360
Asai Chū, 421
Association of German Graphic Artists (Bundes Deutscher Gebrauchsgraphiker), 15
Association of Practical Print Arts (Jitsuyō Hanga Bijutsu Kyōkai), 34, 419, 424
Atelier, 130

B

Bauer Type Foundry, 29
Bauhaus, 17, 26, 37, 40, 176, 244, 262, 406, 420
Bayer, Herbert, 26
Bernhardt, Sarah, 48, *49*
bijinga (pictures of beautiful women), 12, 19, 30, 60
book covers, 360
bookplates, 360
Boys' Day (*Tango no Sekku* or *Kodomo no Hi*), 88
Bunpōdō, 214, 288

C

Cahiers d'art, 360
Calpis, 206, 234, 324
Campari liqueur, 302
cartoons, advertisements with, 32, 244, *245–61*
catalog design, 360, *361–73*
Chéret, Jules, 48
chōchin (paper lantern), 130, 374
cinema letters (*kinema moji*), 23, 234
Commercial Art, 15, 16, 34, 420

commercial art (*shōgyō bijutsu*)
 coinage of term, 12
 definition of, 11–12
 Hamada's theory of, 12, 18, 34–37, 39, 406, 414–18
Commercial Artists Association (Shōgyō Bijutsuka Kyōkai)
 acronym of, 11, 43 (note 9), 158
 chapters of, 34
 founding of, 12, 33–34, 406, 419, 420, 422
 original members of, 33, 43 (note 14)
Commercial Art Monthly, 10, *11*, 46
The Complete Commercial Artist (*Gendai shōgyō bijutsu zenshū*; TCCA). *See also individual themes and artists*
 color lithographs in, 46
 comprehensiveness of, 46, 47
 importance of, 11, 41–42
 order of publication for, 43 (note 5)
 organization of, 10, 46
 page dimensions of, 47
 page numbers in, 47
 price of, 10
constructivism, 17, 37, 48, 80, 398, 406
container design. *See* wrapping paper and container design
copywriting, 302, *303–9*
Le Corbusier, 35, 406, 414, 418 (note 2)
Coty perfume, 302
Creation of the Universe Society (Sōusha), 426
Creative Age (*Sōsaku Jidai*), 360
crests, 28, 324
Crystal Palace, 206

D

Dada, 406
Daimaru department store, 29, 324
decorations
 exhibition display, 206, *207–13*
 street sales, 11–12, 186, *187–205*
decorative letters (*sōshoku moji*), 44 (note 36)
design letters (*ishō moji*), 44 (note 36)
Dexel, Walter, 17
Dunlop tires, 302
Dwiggins, William Addison, 13

E

Edison, Thomas, 158
Edo period, 16, 18, 26, 28, 48, 324, 374
Eiffel, Gustave, 158
electricity, advertisements with, 158, *159–75*
exhibition display decorations, 206, *207–13*
expressionism, 48, 422, 423

F

family crests (*kamon*), 324
fat Kanteiryū (*futo Kanteiryū*), 28, *28*
flyer design, 310, *311–23*
Frenzel, H. K., 15–16
Fujisawa Tatsuo, 34, 419
Fujishima Takeji, 422
Futura, 29
futurism, 406, 422

G

Gebrauchsgraphik (*Commercial Graphics*), 15, 16
Gekkeikan sake, 29
Gilka liqueur, 80
Ginza candy, 244
Ginzburg, Moisei, 406
Girls' Day (*Hinamatsuri*), 88
Gothic lettering, 262
Greenhalgh, Paul, 18
Great Kantō Earthquake, 21, 302, 426
Gropius, Walter, 420, 426
Group of Seven (Shichininsha), 20, 33, 45 (note 49), 45 (note 51), 419, 424
Guerlain perfume, 302

H

Hakutsuru sake, 29, 324
Hamada Masuji
 biography of, 419–20
 as founding member of the Commercial Artists Association, 12, 33–34, 43 (note 14), 158, 406
 influence of, 33, 40
 as lead editor of *The Complete Commercial Artist*, 11, 33–37, 39–40, 46, 48, 420
 theory of commercial art of, 12, 18, 34–37, 39, 406, 414–18
hand-designed lettering (*kaki moji*), 23
Harada Jirō, 16–17, 34
Hara Hiromu, 23, 30
Hara Mansuke, 43 (note 14)
Hermes whiskey, 234
hiragana (syllabary), 22, *22*, 23, 25, 262
The Housewife's Companion (*Shufu no tomo*), 19

I

Ichikawa dynasty, 214
Ikegami Shigeo, 43 (note 14)
illustration design, applied, 288, *289–301*
Isetan department store, 324
Ishimoto Kikuji, 420
Itoya, 214
Itten, Johannes, 425

J

Japanese character styles
 advertising letters (*kōkoku moji*), 44 (note 36)
 anomalous letters (*hentai moji*), 44 (note 36)
 cinema letters (*kinema moji*), 23, 234
 decorative letters (*sōshoku moji*), 44 (note 36)
 design letters (*ishō moji*), 44 (note 36)
 fat Kanteiryū (*futo Kanteiryū*), 28, *28*
 hand-designed lettering (*kaki moji*), 23
 Kantei-style characters (*Kanteiryū*), 28, *28*
 peony characters (*botan moji*), 28, *28*
 square characters (*kakuji* or *kakumoji*), 28, *28*
 standard letters (*hyōjun moji*), 26
 sumo script (*sumō moji*), 28
 whisker characters (*hige moji*), 28, 29
Japonisme, 14
Jintan medicinal candy, 158
JOAK (radio broadcasting company, now NHK), 398
Jugendstil, 48

K

Kabuki theater, 28, 48, 214, 262
kana, 22
Kandinsky, Wassily, 406
Kaneko Hiroshi, *30*
kanji, 22, *22*, 25
Kanokogi Takeshirō, 421
Kantei (Okazakiya Kanroku), 28
Kantei-style characters (*Kanteiryū*), 28, *28*
Kaō Soap, 234
Kassák, Lajos, 17
katakana (syllabary), 22, *22*, 23, 25
Kawahata Naomichi, 14, 23
Kikkoman soy sauce, 234, 324
Kinokuniya, 214
Kirin beer, 206, 234, 324, 424
Kitahara Hakushū, 43 (note 3)
Kitahara Tetsuo, 43 (note 3)
Kitahara Yoshio, 43 (note 3)
Kodak film, 80
Kolodziej, Magdalena, 414
Kon Wajirō, 130
Kotobukiya, 262
Kurahara Korehito, 406
Kurata Chikatada, 420–21
Kuroda Seiki, 19, 20, 33, 424

L

label design, 310, *311–23*
Lang, Fritz, 118
layout, 23, 25, 302, *303–9*
leaflets, 310

lettering design, 22–23, 25–26, 28–29, 262, 263–87
Lion toothpaste, 60, 158, 420
Lissitzky, El, 37
Little Rascals, 31
logos, 234, 324
luggage labels, 310
Lunacharsky, Anatoly, 406

M

Madelios menswear, 398
Maekawa Senpan, 32, 42, 421
magazines
 advertisements in, 234, 235–43
 covers of, 360
Malevich, Kazimir, 39
manga, 32, 244, 421, 422–423, 424
mannequins, 80, 87, 88, 89, 398, 425
Marubishi clothing store, 45 (note 49)
Marunouchi Building (Maru Biru), 45 (note 49)
Maruzen, 39, 206, 310
matchbox labels, 310
Mavo, 26, 422
Meiji chocolate, 234
menus, 334
mimasu, 214
Mitsui Gofukuten, 374
Mitsukoshi (magazine), 20
Mitsukoshi department store
 designers for, 19, 424
 flyers from, 310
 Group of Seven's exhibition at, 45 (note 51)
 monogram of, 29, 324
 posters of, 18, 60
 predecessor of, 374
Miyao Shigeo, 421
Miyashita Takao, 11, 14, 421
Mizono tea, 302
modern boy (*mobo*), 60, 100, 176, 234
modern girl (*moga*), 60, 234, 288, 334
modernism, 35, 40, 41, 398, 406, 426
Moholy-Nagy, László, 26, 30, 406
monograms, 25, 29, 324, 325–33
Moriguchi Tari, 406
Morinaga confectionery, 234, 324, 422
Murayama Tomoyoshi, 26, 39, 406, 421–22
Murota Kurazō, 33, 34, 34, 43 (note 14), 422

N

Nakada Sadanosuke, 11, 17, 244, 422
Nakajima Shunkichi, 43 (note 14)
Nakamura-za, 28
Naritaya theater, 214
Natsume Sōseki, 360

nenjū gyōji (annual activities), 88
newspaper advertisements, 234, 235–43
new typography movement, 26, 29, 48, 398
new woman (*atarashii onna*), 20, 60
nobori (vertical banner), 374
noren (doorway curtains), 324, 374
noshi motif, 88

O

Okada Saburōsuke, 18–19
Okamoto Ippei, 421, 422–23
Okamura Bunzō (Yamaguchi Bunzō), 426
Okazakiya Kanroku (Kantei), 28
Okuyama Gihachirō, 34
Onchi Kōshirō, 423
Oranda Bookstore, 43 (note 3)

P

pamphlet cover design, 360, 361–73
pattern design, 334
peony characters (*botan moji*), 28, 28
Phillips, Christopher, 30
photography, advertisements with, 30–32, 244, 245–61
playbills, 360
Plekhanov, Georgi V., 406
posters
 from all over the world, 48, 49–59
 designs for practical, 60, 61–79

Q

Quinquina wine, 398

R

Rading, Adolf, 176
Red Cow condensed milk, 244
Die Reklame (*The Advertisement*), 14
Renner, Paul, 29
romanized letters (*rōmaji*), 22, 22, 23, 262

S

Saitō Kazō, 423
salaryman (*sararīman*), 32, 60, 244
sans serif typefaces, 26, 29, 398
Satomi Munetsugu, 16
Schmidt, Joost, 26
Schmidt, Kurt, 40
School of Commercial Art
 (Shōgyō Bijutsu Kōsei Juku), 34, 420
School of Paris, 48
Secessionist Architecture Association
 (Bunriha Kenchikukai), 420, 426

Die Sechs, 48
Seibundō, 34, 422
senjafuda (votive slips), 374
Shibazono cinema, 360
Shishido Sakō, 424
Shishindo (bookstore), 214
Shōchiku cinema, 360
show windows
 backgrounds for, 100, *101–17*
 equipment for, 88, *89–99*
 world model, 80, *81–87*
signboards (*kanban*)
 from all over the world, 118, *119–29*
 designs for practical, 130, *131–57*
small printed matter, 334, *335–59*
Smoca toothpaste, 234, 302
square characters (*kakuji* or *kakumoji*), 28, *28*
standard letters (*hyōjun moji*), 26
De Stijl, 17, 39, 40, 406
store interior equipment, 176, *177–85*
street sales decorations, 11–12, 186, *187–205*
The Studio, 14
Sugisaka Chinkichi, 43 (note 14)
Sugiura Hisui, 10, *10*, 11, *19*, 19–21, 60, 424
sumo script (*sumō moji*), 28
Sun Studio, 424
suprematism, 39, 406
Suyama Hiroshi, 43 (note 14)

T

Tada Hokuu, 33, 34, 43 (note 14), 424
Taishō period, 25
Taishō romanticism, 25
Tajima Natsuko, 34
Takashimaya department store, 29, 324
Takeda Gōichi, 23, 25
Takehisa Yumeji, 360, 423, 425
Takei Takeo, 425
Tama Imperial Art School (Tama Teikoku Bijutsu Gakkō), 21, 419, 424, 426
Tanaka pens, 158
Tanizaki Junichirō, 244
Tatsuke Yoichirō, 11, 425–26
Telefunken radios, 80
Teltscher, Georg, 40
Tokyo Higher School of Arts and Technology (Tōkyō Kōtō Kōgei Gakkō), 11, 14, 420, 421, 424, 426
Tokyo Prefectural Museum, *33*, 45 (note 49), 45 (note 54)
Tomita Morizō, 34, 43 (note 14)
Tonca Toys, 262
Toppan Printing Company, 419, 424

Toulouse-Lautrec, Henri de, 48
trademarks, 25, 234, 324, *325–33*
Tschichold, Jan, 26
typefaces
 Edo commercial scripts standardized as, 26, 28
 Futura, 29
Typographic Handbook (*Zuan moji taikan*), 23, 426

V

van Doesburg, Theo, 39
Vantongerloo, Georges, 40

W

Watanabe Soshū, 11, 426
Waterman pens, 398
whisker characters (*hige moji*), *28*, 29
Wiener Werkstätte, 360
Wildhagen, Eduard, 16
wrapping paper and container design, 214, *215–33*

Y

Yajima Shūichi, 23, 25, 34, 426
Yamada Shinkichi, *23*
Yamaguchi Bunzō (Okamura Bunzō), 426
Yamasa soy sauce, 324
Yokohama Rubber, 420
Yoshida Shōichi, 43 (note 14)
Yoshikawa Shōichi, 43 (note 14)
Young Grass (*Wakakusa*), 360

CREDITS & ACKNOWLEDGMENTS

All images © Letterform Archive unless noted. All objects collection of Letterform Archive unless noted.

All artwork still in copyright is registered with the artists' estates, heirs, or appointed licensing agencies. The publisher has made every attempt to locate the proper heirs and agencies for artwork still in copyright. Please contact Letterform Archive Books with any questions or corrections pertaining to credit or copyright.

TEXT CREDITS

A version of this book's introduction was first published as "Japanese Modernism and Consumerism: Forging the New Artistic Field of 'Shōgyō Bijutsu' (Commercial Art)" in *Being Modern in Japan: Culture and Society from the 1910s to the 1930s*, ed. Elise K. Tipton and John Clark (Honolulu: University of Hawai'i Press, 2000), 75–98; and additional sections were previously published in "Japanese Typographic Design and the Art of Letterforms" in the first volume of *Bridges to Heaven: Essays on East Asian Art in Honor of Professor Wen C. Fong*, ed. Jerome Silbergeld and Dora C. Y. Ching (Princeton, NJ: Tang Center for East Asian Art and Princeton University Press, 2011), 827–48. Magdalena Kolodziej's translation from Hamada Masuji's "Introduction to Commercial Art" first appeared in *Review of Japanese Culture and Society* 28 (2016): 74–79. All texts are reprinted with permission of the publishers.

CREDIT, COPYRIGHT, AND IMAGE SOURCES

PAGE 19 Photo courtesy of The Museum of Art, Ehime.

PAGE 20 (LEFT TO RIGHT) Image courtesy and collection of The Museum of Art, Ehime · Image courtesy and collection of National Crafts Museum/DNPartcom; photography by S & T Photo © 2021 · Image courtesy of The Museum of Art, Ehime.

PAGE 21 (LEFT TO RIGHT) Image courtesy and collection of The Museum of Art, Ehime · Images courtesy and collection of National Crafts Museum/DNPartcom; photography by Shunji Tanaka © 2008.

PAGE 23 Image courtesy and collection of Kyoto Institute of Technology, Museum and Archives, AN.2694-29.

PAGE 37 (TOP AND MIDDLE) Image courtesy and collection of Kunstmuseum Moritzburg Halle (Saale) · © 2023 Artists Rights Society (ARS), New York/UPRAVIS, Moscow; image courtesy of Alamy/State Tretyakov Gallery, Moscow.

ACKNOWLEDGMENTS

Thank you to Kate Long Stellar and Paola Zanol for collections assistance; April Harper and Ellis Martin for digitization; Katy Bridges and Dr. Masahiko Minami for translation assistance; and Kate Bolen, Ken DellaPenta, and Gail Nelson-Bonebrake for editorial assistance.

Letterform Archive

2339 Third Street, Floor 4R
San Francisco, CA 94107
letterformarchive.org

PUBLISHER EMERITUS
Rob Saunders

PUBLISHER
Lucie Parker

ACQUISITIONS EDITOR
Chris Westcott

ASSOCIATE MANAGING EDITOR
Molly O'Neil Stewart

EDITORIAL ASSISTANT
Khoo Zi Yun (Geraldine) Ang

ART DIRECTOR
Alice Chau

PRINT PRODUCTION MANAGER
Thomas Bollier

ABOUT LETTERFORM ARCHIVE BOOKS
Founded in 2015 in San Francisco, Letterform Archive is a nonprofit center for design inspiration. Letterform Archive Books produces titles based on its collection of more than 100,000 artifacts spanning the history of graphic design, type design, and lettering. Its critical editions present rare materials from its collection in full color, preserving the experience for future readers. These materials, presented for the purposes of historical veracity, may sometimes contain original text and artwork that contemporary audiences reject as problematic, which we endeavor to address in the supplemental text.

This book's running text is set in Greycliff CF, a sans serif typeface by Connary Fagen. Japanese kanji and kana are set in M Plus Rounded by Coji Morishita. Condensed numerals and volume titles are set in Rocky Compressed, designed by Matthew Carter and Richard Lipton. Numerals for volume openers are set in Mojiwaku Kenkyu's Pigma 01, a typeface inspired by the lettering of Japanese designer Hirano Kōga.

A note on navigation: References to reproductions from the original volumes of *The Complete Commercial Artist* use this book's page numbers rather than the page numbers of the original.

© 2024 Letterform Archive Books
All rights reserved, including the right of reproduction in whole or in part or in any form.

Available through ARTBOOK | D.A.P.
75 Broad Street, Suite 630
New York, NY 10004
www.artbook.com

ISBN: 978-1-7368633-4-3

Library of Congress Control Number:
2023941794

10 9 8 7 6 5 4 3 2
2024 2025 2026 2027 2028

Printed in China by 1010 Printing